IMAGES
of America

THE
WEST VIRGINIA
TURNPIKE

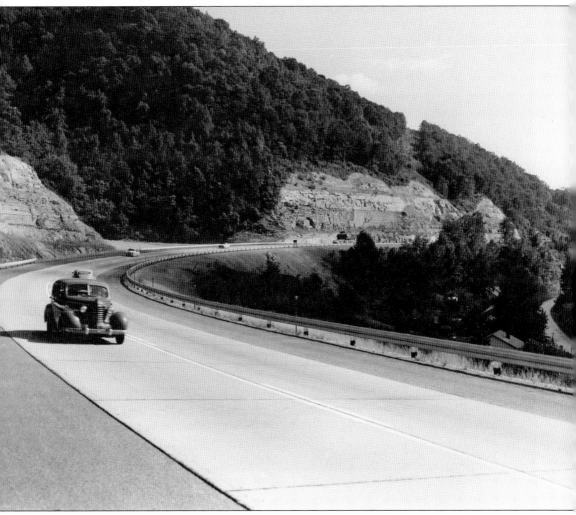

The 88-mile West Virginia Turnpike had dual openings in 1954 and 1955, with the southern branch dedicated to great national fanfare on September 2, 1954. The *Detroit Free Press* opined that the turnpike's sponsors had "faith that literally moved mountains." The photograph here shows a 1937 Oldsmobile sedan rolling through Kanawha County on a smooth highway surface—a rarity in central West Virginia at the time. (Courtesy of the West Virginia Parkways Authority.)

ON THE COVER: One of the most impressive structures of the West Virginia Turnpike was the combination Memorial Tunnel and Stanley Bender Bridge that traveled through Paint Mountain and over Paint Creek. The $5 million, two-lane tunnel was completed in 1955. The Stanley Bender Bridge stands 278 feet above the valley floor and was—at the time of its construction—the highest span east of the Mississippi River. (Courtesy of the West Virginia Parkways Authority.)

IMAGES
of America

THE
WEST VIRGINIA
TURNPIKE

William R. "Bill" Archer

ARCADIA
PUBLISHING

Copyright © 2023 by William R. "Bill" Archer
ISBN 978-1-4671-0981-9

Published by Arcadia Publishing
Charleston, South Carolina

Printed in the United States of America

Library of Congress Control Number: 2022951506

For all general information, please contact Arcadia Publishing:
Telephone 843-853-2070
Fax 843-853-0044
E-mail sales@arcadiapublishing.com
For customer service and orders:
Toll-Free 1-888-313-2665

Visit us on the Internet at www.arcadiapublishing.com

I dedicate this book to all the men and women—artists, artisans, and crafters—who dedicate their time, talents, and energy to the maintenance, operations, planning, and leadership that make this remarkable 88-mile section of highway through "Almost Heaven" truly a year-round travel adventure. In addition, I dedicate this work to the 13 men who died while working on the initial phase of this project, along with the children, women, and men who have perished in accidents on this highway through the years. May they never be forgotten.

CONTENTS

Acknowledgments

This book would not have been possible without the encouragement of many people. First and foremost, thanks go to the staff of Arcadia Publishing, especially Katelyn Jenkins, acquisitions editor, and Caitrin Cunningham, senior title manager, for assistance with my recent books in Arcadia's Images of America series. I thank Randall and Carrol Hash for their incredible aerial (drone) photographs that provide a bird's-eye view of the turnpike. Also, I would not have tackled this project without the assistance of Mercer County Commission administrator Vicky Reed. In addition to her painstaking eye for detail, she encouraged me to tackle this project, which examines another significant aspect of southern West Virginia history. Our Mercer County Commission team, which includes president Gene Buckner, commissioner Greg Puckett, Vicky Reed, and receptionist Robin Hess, works together in service to the people of Mercer County.

West Virginia Turnpike Authority executive director Jeff Miller, his administrative assistant Robin Shanklin, and the entire West Virginia Parkways Authority Board of Directors have been partners in this project, as has the management of Tamarack. Special thanks go to my partner-in-history, John Velke, creator of the One Thin Dime Museum, as well as to Becky Kauffman, archivist of Craft Memorial Library; Julie Mayle, curator of manuscripts at the Rutherford B. Hayes Presidential Library & Museum; Joscelyn White, GIS specialist, of Region 1, Appalachian Regional Commission; Amber McPherson of the West Virginia Parkways Authority, West Virginia Welcome Center; Ginger Boyles, *Bluefield Daily Telegraph*; and my grandson Seth Orion Morgan; his wife, Erykah; and their son, Theodore, of Point Pleasant, West Virginia.

INTRODUCTION

Travel through the Appalachian ridge and valley plateau of the Allegheny Mountains posed challenges to the indigent First Nations people of central Appalachia long before Europeans arrived in North America. The discovery of Clovis-era projectile points in southwestern Pennsylvania indicate that people lived in the Alleghenies thousands of years before the Christian era. Trade items uncovered in archaeological digs in south-central West Virginia and southwestern Virginia reveal that indigenous people traded with the so-called Mound Builders (Adena) people of southwestern West Virginia and south-central Ohio as well as Fort Ancient peoples of the same region who lived in the region until about 1750. Fort Ancient trade items have been discovered in Mercer County, West Virginia, revealing that robust trade routes had been well established before and during European colonization of North America.

Without a comprehensive written account of the pre-Columbian people of North America, their story cannot be fully appreciated. And with the waning public interest in the painstakingly slow process of detailed archaeological studies of known sites where North America's first residents lived, their story remains mostly untold. Even still, some little-known arrowhead hunters have made fascinating discoveries that demonstrate a level of sophistication among early inhabitants of the central Appalachian region largely overlooked by the waves of colonists who swept through the Appalachian region. Lee Lilly Jr. of Flat Top, West Virginia, has spent decades searching for First Nation artifacts primarily in Raleigh and Mercer Counties. His "map stone" found near Gauley Bridge helped native travelers follow rivers through the mountains. A large carved stone found in Bland County, Virginia, may show a representation of the planetary movements in our solar system. Others might see something else in the unique stone, but there is no question that the 300-plus-pound stone has some significance.

Colonial warriors traveled First Nations trails to battle Indians in "Lord Dunsmore's War," the British Redcoats in the American Revolution, and brother against brother in the American Civil War. Still, it was Germany's autobahn that quickly carried troops to multiple battlefronts that planted the seeds of an interstate highway system in the United States.

The popularity of automobiles grew slowly in the years immediately following Karl Friedrich Benz of Mannheim, Germany, perfecting the internal combustion engine in 1883. By the second decade of the 20th century, America started a love affair with Henry Ford's affordable Model T Ford, and so, the popularity of automobiles grew much faster than the roads they could travel. In 1926, the US government worked to create a comprehensive federal highway system. The route they selected through south-central West Virginia followed a combination of Indian trails, oxcart paths, stagecoach lines, and long-forgotten trails, including the Raleigh-Grayson Turnpike that was carved out prior to 1863 when West Virginia became the 35th state.

US Route 21 was popularly called "the Great Lakes–to–Florida Highway" but only made it from Cleveland, Ohio, on Lake Erie to Hunting Island, South Carolina. It was a four-hour trip from Princeton, West Virginia, to Charleston, West Virginia, but longer still when severe rain or

snowstorms blanketed the mountain terrain. After the end of World War II, the West Virginia State Legislature set a plan in motion that would ultimately open the southernmost counties of West Virginia to the 21st century.

To a modern traveler, the West Virginia Turnpike likely resembles most interstate highways in the United States and the world, for that matter. Sure, the mountains are beautiful with four distinct seasons, but many motorists travel with a singular thought in mind—to get from one place to a different destination. In general, turnpikes nationwide have those pesky tollbooths that often subtract precious minutes from travel schedules. A mere mention of turnpike tolls in southern West Virginia are often "fightin' words." In truth, when it opened in 1955, the West Virginia Turnpike was nothing less than a modern marvel with only two lanes.

Nationwide newspapers described the West Virginia Turnpike as "a miracle of engineering" and "a motorist's dream." Indeed, erecting an 88-mile highway through the heart of the Appalachian Plateau in West Virginia was a monumental feat. Expanding to four lanes meant carving a right-of-way through Paint Mountain and relocating the Stanley Bender Bridge that had previously stood at the southern mouth of the Memorial Tunnel. Upgrading the 88-mile length of the turnpike to interstate standards proved to be another Herculean task while maintaining, patrolling, and repairing this highway in the clouds proved costly. The turnpike authority let new bonds to cover ongoing upkeep, improvements, and maintenance. Tolls increased, and even with the development of a cost-saving E-ZPass program that was marketed to and embraced by many West Virginians, many continued to clamor for the removal of the tolls. In the late 1980s, the authority removed a number of the side-road tollbooths, but some in the public still complained.

However, developments along the turnpike right-of-way emerged at warp speed. The Greater Charleston–Kanawha City commercial, professional, and residential areas expanded up the Kanawha River to Chelyan. Commerce surrounding the southern cities of Beckley and Princeton experienced terrific growth around Exits 44 and 9, respectfully, and traffic counts on both the north-south Interstate 77 corridor as well as the west-east Interstate 64 corridor have grown exponentially. Along with growth on the city exits on the turnpike, attractions like Winterplace Ski Resort, the beautiful Glade Springs Resort, conference centers, golf courses, and residential areas saw an increase in people and traffic.

During the 1980s, the West Virginia Turnpike caught up with highways in the north and actually advanced highway construction practices en route to becoming a stellar example for any and all highway projects built through unforgiving, mountainous terrain. With additional bonds, the parkways authority was able to cut through Paint Mountain to bypass the Memorial Tunnel and the original Bender Bridge. A new bridge was named in honor of Stanley Bender, a Medal of Honor recipient from World War II.

Also, in the 1980s, the turnpike removed most side-road tolls, developed Tamarack—a crucible for Mountain State artists and crafters—and cut the ribbon for a major interstate crossroads, Interstates 79 and 64, with both highways connected from Charleston to Beckley. Turnpike engineers maintain an aggressive highway resurfacing and bridge deck restoration schedule. In addition, the snow and ice removal during winter months is unrivaled in the Appalachian Mountains region.

Along with an ever-increasing flow of traffic on both Interstate 77 as well as the approximately 40 miles that the turnpike shares with Interstate 64 from Charleston to Beckley, West Virginia, parkways authority maintenance crews respond to severe weather challenges and mountain vegetation. Through the years, parkways personnel has learned how to anticipate those challenges in order to protect the traveling public. The incredible story of this unique pathway through the Appalachian Mountains follows.

One

PRE- AND POST-COLUMBIAN TRAILS

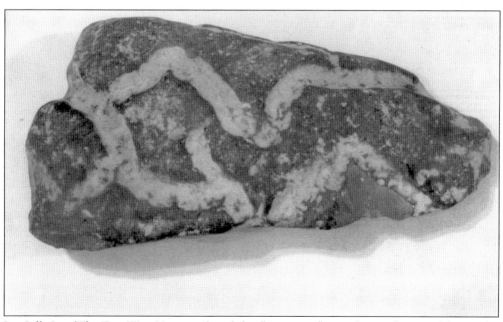

Lee Lilly Jr. of Flat Top, West Virginia, found this "map stone" near the confluence of the Gauley and New Rivers that form the Kanawha River. First Nations peoples of the Appalachian Region traveled extensively through the area for hunting, trade, and war. The Kanawha River was a key thoroughfare for pre-Columbian people in what is now south-central West Virginia. (Courtesy of One Thin Dime Museum.)

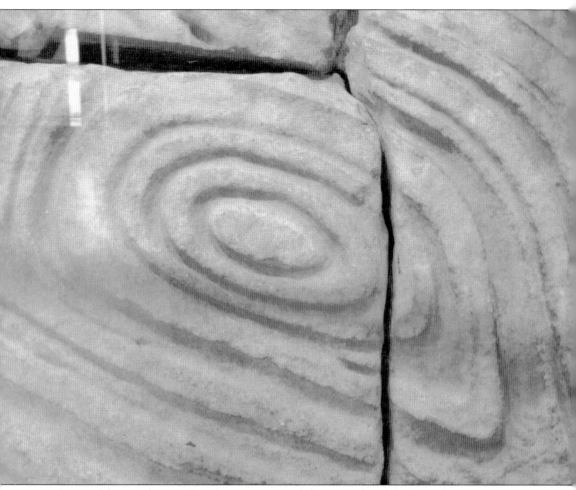

This carved stone that was found in four pieces is about four by three feet in diameter and weighs about 300 pounds. It was discovered on a mountain in Bland County, Virginia, 70-plus years ago. Bland County was one of the counties the Commonwealth of Virginia cleared while building the Raleigh-Grayson Turnpike. The stone is now displayed at the Bastian Indian Village Museum, a facility that was built near the site of a major First Nations village that was discovered during the construction of Interstate 77 in Virginia. While the meaning remains unknown, with a central oblong object surrounded by five or six circles with as many as four outer elliptical circles, the carving could be that of Earth's solar system. (Photograph by the author.)

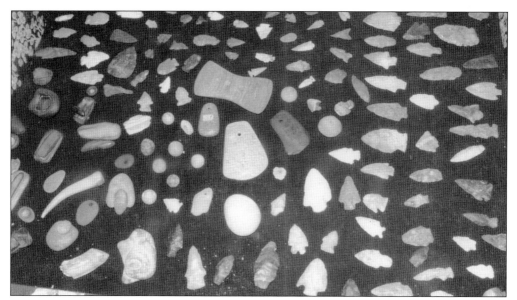

This partial display of Lee Lilly Jr.'s First Nations artifact collection includes a large number of Woodland period projectile points along with a few that appear to be styled similar to Clovis points. In addition to the points, there are several other tools in the display. Lilly discovered most of the artifacts in Mercer and Raleigh Counties in West Virginia. The display is housed in the One Thin Dime Museum in Bluefield, West Virginia. (Photograph by the author.)

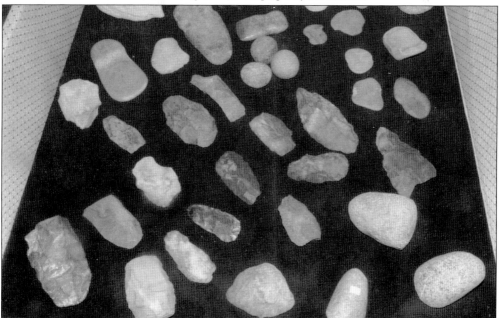

First Nations people of the Central Appalachian primarily used stone to fashion tools prior to European colonization that started in the late 16th and 17th centuries. Here, the artifacts include axe heads that were used in woodworking and warfare, scrapers used in preparing hides for tanning, and spherical balls used in games. First Nations people quickly adopted metal brought to North America by colonists for similar uses as the tools seen here. This image is of the Lee Lilly Jr. Collection at the One Thin Dime Museum. (Photograph by the author.)

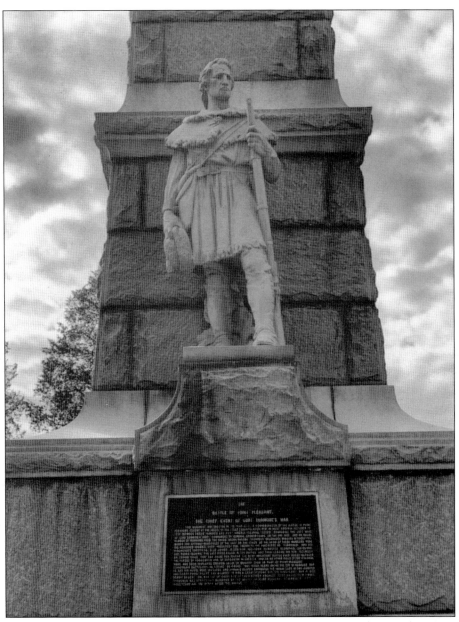

Col. Andrew Lewis, a native of Ireland, first came to North America with his family. His father, Col. John Lewis, had served in the British army but brought the family to Virginia in 1732 where they settled in Augusta County. Andrew Lewis served as county lieutenant in the Augusta militia and rose to the rank of captain while serving under George Washington in the Virginia regiment. In 1774, John Murray, the fourth earl of Dunmore and governor of Virginia, led a force to Fort Pitt and ordered Lewis to take the Augusta militia on a more southerly route to the Ohio River. The Battle of Point Pleasant occurred on October 10, 1774, between Lewis's Virginia militia, more than 1,000 strong, and a First Nations force that included members of the Delaware, Mingo, Iroquois, Wyandott, and Shawnee Nations. The Virginians won in the battle, nicknamed "Lord Dunsmore's War." Some historians consider this battle to be the first one of the American Revolution. (Courtesy of Seth Morgan.)

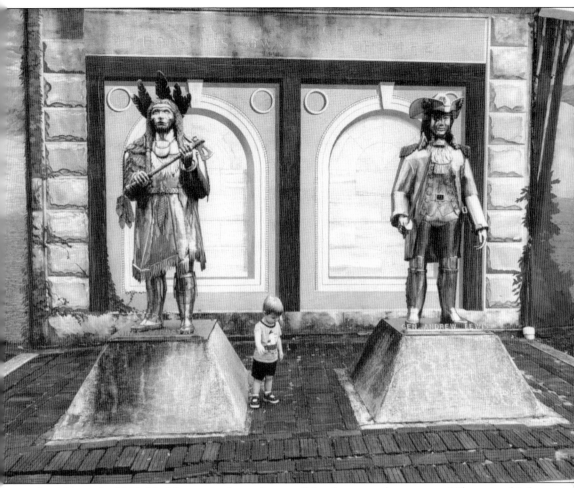

An 18-month-old Teddy Morgan is shown here walking between the statues of Shawnee chief Cornstalk (left) and Gen. Andrew Lewis (right), located at Tu-Endie-We Park at the confluence of the Ohio and Kanawha Rivers at Point Pleasant, West Virginia. Tu-Endie-We is a Wyandott Nation word that means "point between two waters." General Lewis had learned a great deal about the region in his civilian work as a surveyor. Chief Cornstalk (Hokolskwa in the Shawnee language) knew the Virginians had better weapons, but the combined leaders of the other nations were determined to end the European incursions into their native lands. In all, 75 men in the Virginia militia were killed, and 140 were wounded. The First Nations combatants killed in the battle were not known due to the fact that both the dead as well as the wounded warriors were removed from the battlefield. (Courtesy of Seth Morgan.)

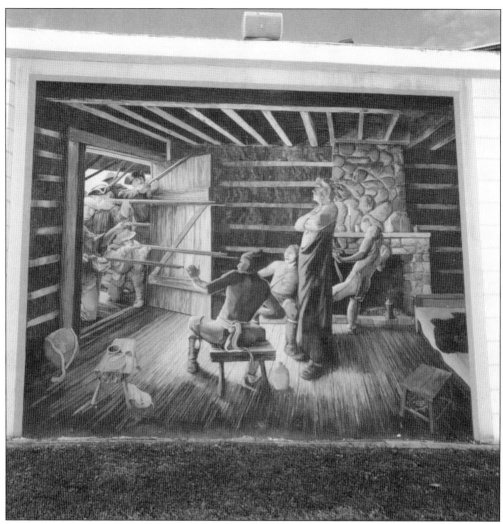

Sachem Hokolskwa, known to the Virginians as Chief Cornstalk, tried to negotiate with the colonists as they moved westward into lands that First Nations people had lived on for centuries prior to first settlers in Jamestown, Virginia. Cornstalk negotiated the uneasy peace after the Battle of Point Pleasant, where the allied nations would not molest travelers or hunt south of the Ohio River. While Cornstalk and his allies remained true to the 1774 treaty, other nations farther west became allied to England at the start of the American Revolution in 1776. In the spring of 1777, Cornstalk of the Shawnee and Delaware chief Red Hawk arrived at Point Pleasant to discuss colonial violence with peaceful nations. The colonial militia held Cornstalk, Red Hawk, and another allied chief until Cornstalk's son Ellinipsico came to learn why his father had been detained so long. Soon after Ellinipsico's arrival on November 10, 1777, a colonial soldier was killed by an Indian party that quickly fled across the Ohio River. Militia charged into Cornstalk's quarters and killed the Shawnee chief, his son, Chief Red Hawk, and a third chief. (Courtesy of Seth Morgan.)

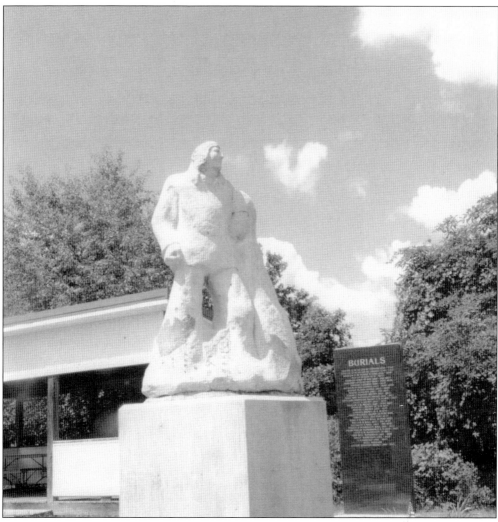

The image of Mitchell Clay is facing outward in this photograph of the statue *Agony in Stone* by West Virginia sculpture Eric Dye, who completed the work in 1977 and presented it to the Mercer County Commission. Mitchell Clay received property in Virginia in return for his service in the Virginia militia. The Clay farm was located on the Bluestone River near the site of a First Nations village that produced relics dating to the pre-Columbian era. In August 1783, Shawnee warriors attacked the Clay farm, killing two of their children—Bartley and Tabitha Clay. The raiders also captured Ezekiel Clay and transported him to a village in Ohio where he was burned at the stake. The Clay family attack was only one of several similar raids that occurred in the years after Cornstalk's murder and the end of the American Revolution. Phoebe Clay is depicted on the reverse side of the sculpture, which is located in the Lake Bottom community. Her image is on the following page. (Photograph by the author.)

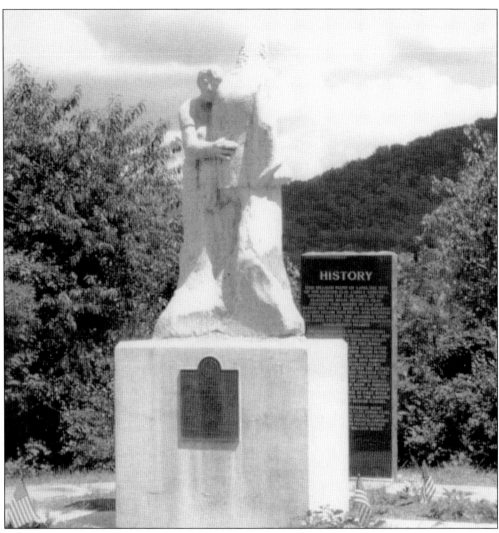

Other similar tragedies include the July 1779 Sluss family massacre in Bland County, Virginia, resulting in the deaths of Jared Sluss, his son James, and his daughters Laura, Hazel, and Christina. The five Sluss family members are buried in a Ceres, Virginia, cemetery. On July 14, 1786, a Cherokee raiding party of 10 or 12 people attacked the family of Capt. James Moore in Abbs Valley, Virginia. Along with James Moore, others killed at the site included sons Andrew and John Moore along with David Sayer, James Coulter, and John and James Simpson. Elizabeth Moore, her daughters, and Rebecca Jane were burned at the stake. Martha Evans and Mary Moore were ransomed in 1787. One final story of local tragedy had a glimmer of a happy ending. Rebecca Davidson was taken in 1791 from the family cabin in Bluefield. She gave birth to a child on the journey who was drowned because of his poor health. Her two daughters, Bartley and Tabitha, were tied to a tree and shot. Another son was drowned, and she was ransomed to a Frenchman living in Canada. Her husband, Andrew Davidson, found his wife in Canada in 1794. Native peoples had well-traveled footpaths through West Virginia from north to south and east to west. (Photograph by the author.)

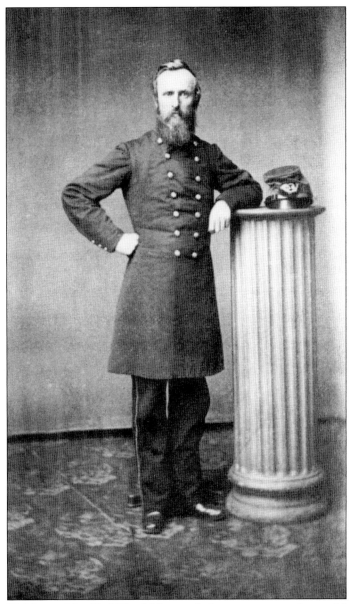

Col. Rutherford B. Hayes of the 23rd Ohio Volunteer Infantry encountered one of the most difficult challenges of the American Civil War—troop movement through the mountains of West Virginia. He moved his regiment with relative ease down eastern Ohio from Cleveland to Point Pleasant, but travel in the mountains of western Virginia relied on a haphazard scattering of "turnpikes," connected loosely by unimproved country roads. When the rains fell, travel was nearly impossible on rutted, un-surfaced roads that could halt cannon wheels in an instant. The spirited group of Ohioans entered the fight to free the slaves and preserve the Union. The 23rd Ohio became one of the Union army's most-traveled units in the Kanawha Division—crisscrossing the state from its base in Charleston to fight at Beverly, Philippi, Carnifiax Ferry, Cheat Mountain, Princeton, Cloyd's Mountain, and South Mountain where, on September 14, 1862, Col. Rutherford B. Hayes suffered a serious wound to his left arm. Although wounded, he remained and urged the 23rd to the top of the mountain. (Rutherford B. Hayes Presidential Library & Museums.)

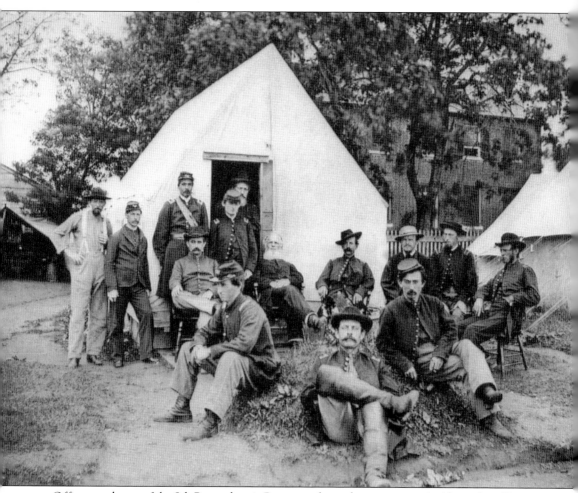

Officers and men of the 8th Pennsylvania Reserves, shown here at a camp in Alexandria, Virginia, fought alongside the 23rd Ohio troops at South Mountain. The Pennsylvania regiment was raised from a mountainous area south of Pittsburgh. Both regiments traveled east to Sharpsburg, Maryland, where, on September 17, 1862, they fought in the Battle of Antietam. The Battle of Antietam was the bloodiest one-day battle in the history of the US military with 23,000 killed, wounded, or missing. The Union army was able to bring a halt to the Army of Northern Virginia's invasion. The success at Antietam gave Pres. Abraham Lincoln the courage to issue the Emancipation Proclamation. Colonel Hayes was not able to lead the 23rd at Antietam due to his wound. At South Mountain, the 23rd Ohio reported 32 killed and 95 wounded. At Antietam, the 23rd had 8 killed and 58 wounded. The 8th Pennsylvania Reserves reported 17 killed and 37 wounded at South Mountain and 12 killed and 43 wounded at Antietam. (From the author's family collection.)

Post–Civil War Virginia and the 35th state, West Virginia, were left in ruins in the closing decades of the 19th century, but if the war proved nothing else, it showed that coal and timber were valuable assets for a new energy-driven economy. It would take until the dawn of the 20th century for electricity to become the industrial revolution's source of power, but mines, like the one shown here in Crumpler, McDowell County, West Virginia, supplied the power for a new world order. Coal promoters, like Jedidiah Hotchkiss, a geologist who served as Stonewall Jackson's mapmaker during the Civil War, promoted the southwestern Virginia and southern West Virginia coalfields as a way to transform Virginia's economy from agricultural to industrial based. Also a city planner, Hotchkiss would later create the design for Kanawha City, West Virginia. (Courtesy of the One Thin Dime Museum.)

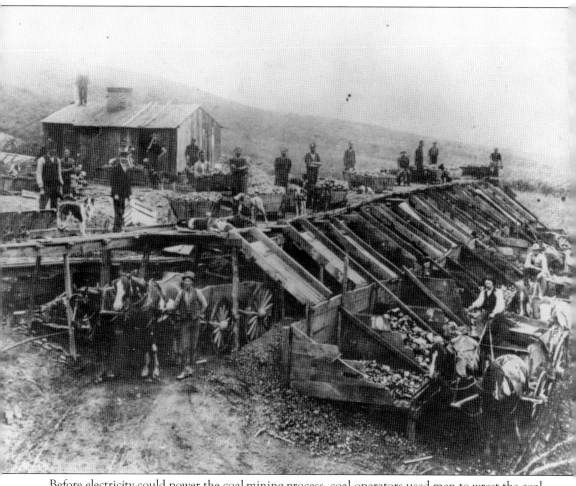

Before electricity could power the coal-mining process, coal operators used men to wrest the coal from the underground coal seams and load the coal on carts where mules and oxen brought it to the surface. In extremely low coal seams, operators used ponies, goats, and dogs, like the ones shown here, to bring the coal to the surface. Once outside the mine portal, laborers separated the coal into a variety of sizes for industrial, commercial, or home use. Workers sent lumps of coal down chutes where other workers loaded mule-team wagons for distribution to customers. In high coal seams, mules were stabled underground. Most mules that were raised underground became blind and learned their routes through repetition. (Courtesy of the One Thin Dime Museum.)

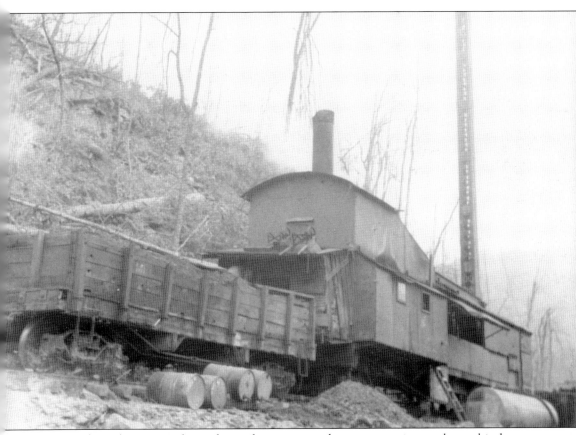

In the early 20th century, the timber industry emerged as a companion to the coal industry throughout south-central West Virginia. Logging companies created living quarters for crews at remote mountain logging sites and faced challenges that all road builders, like First Nations people and colonial settlers—transportation of any kind through West Virginia's mountains is a difficult proposition. (Courtesy of the US Forest Service.)

Both the coal and timber industries relied on rails to transport coal and timber to customers. When the first Europeans began arriving on the East Coast of North America, they were amazed by the abundance of timber in the New World. Within a few years, several East Coast forests had been cleared. Although farther away, in the 19th century the diverse forests of the Appalachian region were much sought after and worth the cost of building railroad tracks to transport the product. (Courtesy of the US Forest Service.)

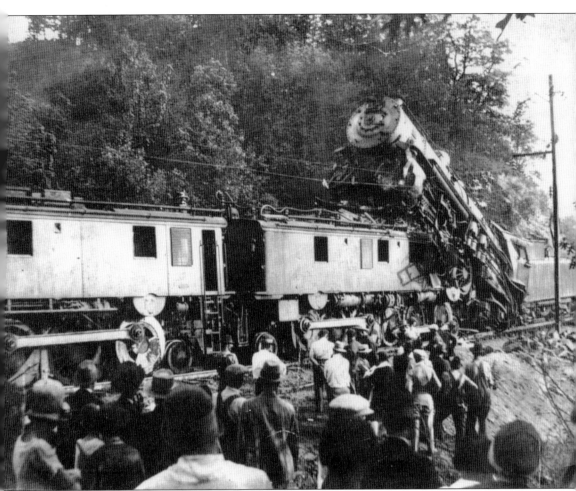

When steam and electric power collided on the Virginian Railroad rails on May 24, 1927, the three crew members in the cab of the coal-powered locomotive died almost instantly. The wreck occurred a few miles west of Princeton, West Virginia. News of the wreck spread quickly, and Blind Alfred Reed, a popular Princeton street musician from the Elgood community in Mercer County, West Virginia, authored the song "Wreck of the Virginian" and used the term "scalded to death by the steam" because news accounts of the tragedy stated that had been the cause of death of the engineer, fireman, and conductor in the locomotive's cab. About a month later, Reed performed the song as well as several others in the famous Bristol Sessions of July 25–August 5, 1927. (From the author's collection.)

One of the first entrepreneurs to consider harvesting the vast hardwood forests of the Appalachian region was Michel Bouvier, a trained cabinetmaker who fought for France in the Napoleonic Wars. When France lost the war in 1815, Bouvier relocated to Philadelphia where he resumed cabinetmaking as well as selling firewood. While in Philadelphia, he became associated with several other French expatriates, and in 1834, he served as the point man in the acquisition of a huge timber tract, almost 800,000 acres, in southern West Virginia and southwestern Virginia. The coal and mineral rights on the tract made Bouvier rich, but he is better known nowadays as a great-great-grandfather of the late Jacqueline (Bouvier) Kennedy Onassis. (Courtesy of the US Forest Service.)

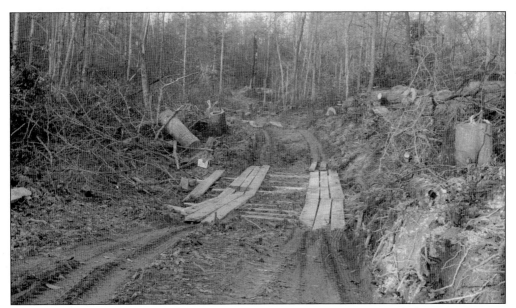

Makeshift bridges like the one shown here provided at least temporary access for lumberjacks to get at the valuable timber that thrived throughout the Appalachian Region. Loggers traditionally did just enough to get to new stands of timber. In some places, inventive loggers made roads through treetops in order to harvest some virgin stands in the mountains. The treetop roads featured pull-off sites where loaded log trucks could pass empty trucks traveling to the top. (Courtesy of the US Forest Service.)

When the loggers completed their harvest, they left rutted roads for farmers and hunters to use. On steeper sections, the loggers carved out series of switchbacks to be able to travel through the mountains. Hunters as well as avid forest hikers frequently find old logging roads in the mountains, which remain to enhance movement through south-central West Virginia. (Courtesy of the US Forest Service.)

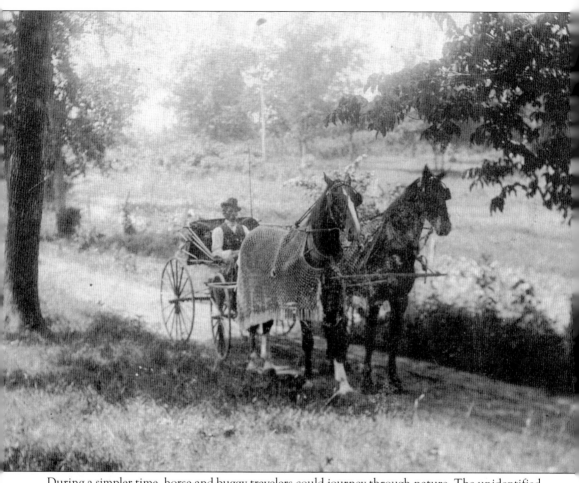

During a simpler time, horse-and-buggy travelers could journey through nature. The unidentified driver pictured here traveled at a pace that did not set speed records but instead provided time for soulful contemplation. Old-timers often called horses "hay burners," but in terms of speed, horses could not compete with steam- or electric-powered locomotives. While unimproved trails enabled horse-drawn conveyances to travel locally, any long-distance travel was most commonly on passenger trains. However, in the twilight years of the 19th century, a new vehicle was about to change travel in a major way. (Courtesy of the Eastern Regional Coal Archives of Craft Memorial Library.)

Two

The Dawn of
the Automobile

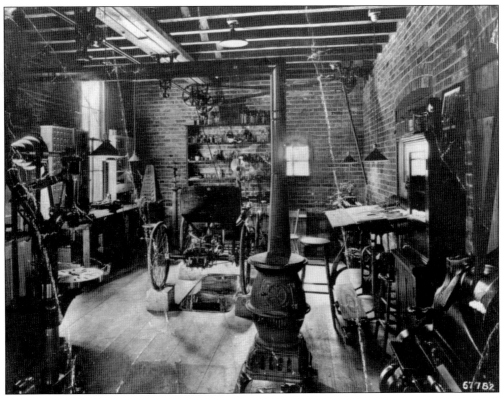

In 1885, a German mechanical engineer, Karl Benz, developed the first vehicle powered by an internal combustion gasoline engine in his Mannheim, Germany, garage, shown here. Benz called his three-wheeled vehicle a "Motorwagon." In the process of inventing his gas-powered vehicle, Benz invented the electric ignition, spark plugs, and the clutch. In 1893, he also developed a four-wheeled vehicle, the Motor Velocipede, also known as the "Vele." In 1926, Benz and Gottlieb Daimler formed Daimler-Benz and manufactured Mercedes-Benz vehicles. (Courtesy of One Thin Dime Museum.)

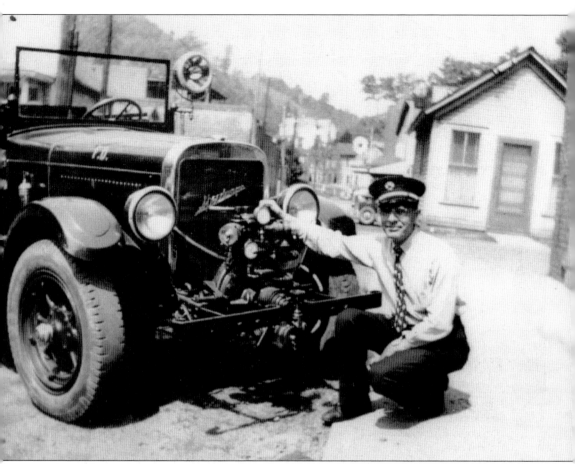

As coal-mining communities of south-central West Virginia and southwestern Virginia grew during the early years of the 20th century, motor vehicles were rare. In fact, the earliest Model T Fords were shipped by freight car and required assembly before they could be driven. As a result, municipalities were more likely to own one of the few vehicles in any town. The unidentified fireman who kneeled in front of his department's REO Speedwagon fire truck and the coalfield community he served are unknown. The REO Motor Car Company began making light motor trucks in 1915. The REO initials derived from the company's founder, Ransom Eli Olds. The light motor truck model was manufactured until after 1953. Neal Dougherty, founder of the rock band REO Speedwagon, came up with the name when he saw it written on a blackboard of his History of Transportation class at the beginning of his sophomore year at University of Illinois, Champaign. (From the author's collection.)

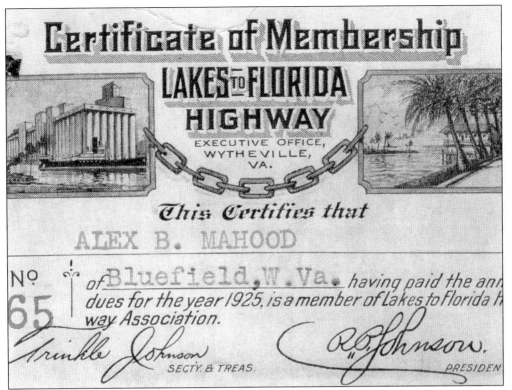

Certificate of Membership
LAKES TO FLORIDA
HIGHWAY
EXECUTIVE OFFICE,
WYTHEVILLE,
VA.

This Certifies that

ALEX B. MAHOOD

NO 65 of Bluefield, W.Va. having paid the ann[ual] dues for the year 1925, is a member of Lakes to Florida H[igh]way Association.

Trinkle Johnson
SECTY. & TREAS.

R.B. Johnson.
PRESIDEN[T]

With the dawn of the 20th century, transportation was almost completely in the public domain. Railroads competed nationally for city-to-city routes, while intra- and inner-city travel was often on electric-powered streetcars. Although automobiles were primarily a novelty enjoyed by wealthy persons, the freedom of traveling outside cities was limited. Various counties, municipalities, and states created disconnected roads, but the federal government took a nationwide approach to solving the matter. In November 1926, the federal government established the US Highway System. The highway that served south-central West Virginia was designated Route 21. (Courtesy of the Eastern Regional Coal Archives.)

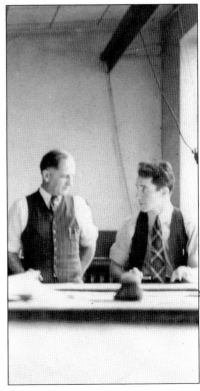

Famed West Virginia architect Alexander B. Mahood (left) is shown here with an assistant, Harry Turner (right), in his penthouse studio on the roof of Bluefield, West Virginia's Law & Commerce Building. Mahood designed scores of homes in Bluefield, but he also designed courthouses in Mercer and Raleigh and several dormitories on the West Virginia University campus, including Boreman Hall and the Towers Dormitories as well as the Creative Arts Center. Mahood was a charter member of the association that sought to build US 21 from Cleveland to Florida. (Courtesy of the Eastern Regional Coal Archives.)

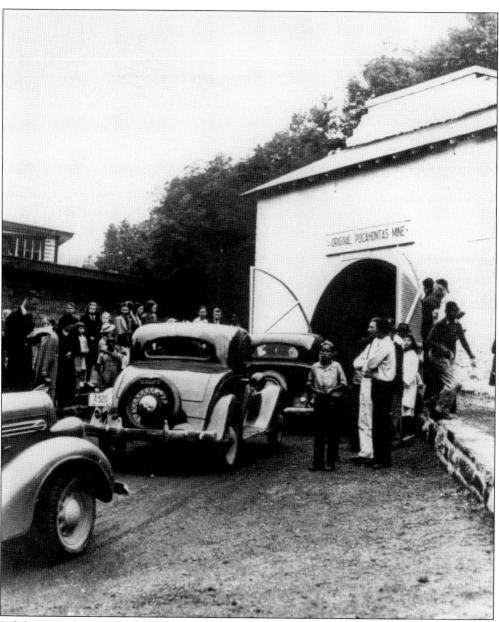

It did not take long for roads to open up and for people to get out to explore some of the places they had read or heard about. The management of the then Pocahontas Fuel Company in Pocahontas, Virginia, decided to open a show mine in the heart of the southwestern Virginia and southern West Virginia coalfields. The original mine, locally called "the Baby Mine," opened in 1882 and sent its first load of coal to Lambert's Point near Norfolk, Virginia, the following year. The Baby Mine played out quickly, but engineers opened the East Mine in 1883 about 200 yards east of the original portal. In 1938, Pocahontas Fuel opened the world's first drive-through in the ventilation shaft of the East Mine. When the East Mine closed in 1955, both it and the Baby Mine had produced a total of 44 million tons of metallurgical coal. Now a mine and museum, the Pocahontas Exhibition Mine is open through the spring-fall tourist season as a pedestrian experience. (Courtesy of the One Thin Dime Museum.)

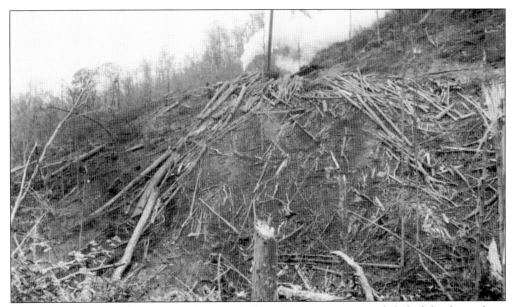

Mountainside timber harvests in the Appalachian Mountains region left fuel for forest fires, prompting the federal government to take steps to protect the nation's vital forest resources. In 1876, Congress created the office of special agent in the US Department of Agriculture to assess the nation's forest. In 1891, large-scale forest burning in the eastern and western United States prompted Congress to authorize Pres. William McKinley to designate public lands as "Forest Reserves." (Courtesy of the US Forest Service.)

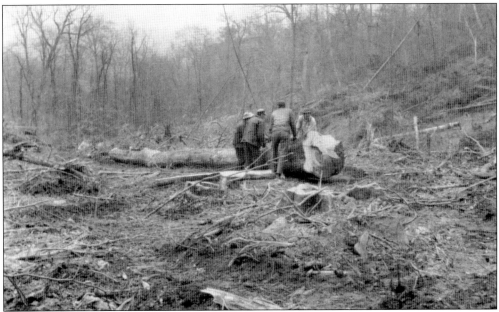

President McKinley served with Col. Rutherford B. Hayes in the 23rd Ohio Volunteer Infantry and was called "the Cowboy President" because of the vigorous ways he promoted forest and land conservation while in the White House. After McKinley's assassination in 1901, Pres. Theodore "Teddy" Roosevelt promoted McKinley's forest conservation cause and created the US Forest Service in 1905. (Courtesy of the US Forest Service.)

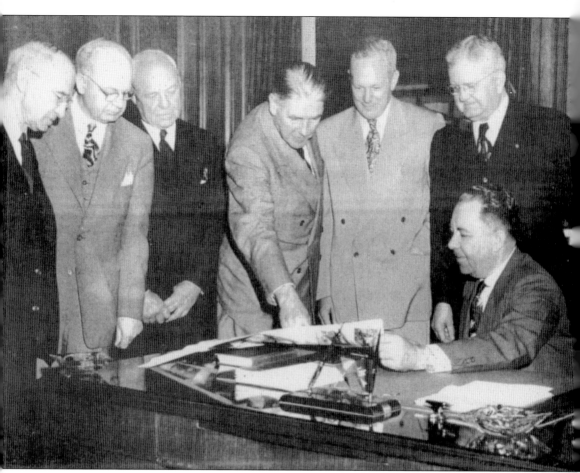

During World War II, American forces in Europe learned firsthand how important the autobahn was to the movement of German troops to confront Allied advances in Europe. The US Highway System was a step in the right direction, but two-lane roads that followed old wagon trails and scattered turnpikes had their own challenges. Still, an estimated crowd of 10,000 people gathered at Flat Top, Mercer County, West Virginia, on October 28, 1926, for the grand opening of US Route 21. Gov. Howard M. Gore proclaimed the event to be "Southern West Virginia's Greatest Day." Still, the four-hour drive from Princeton to Charleston was anything but easy. However, 20 years later, on October 25, 1949, Gov. Okey Leonidas Paterson, who served from 1949 to 1953 and is shown seated at his desk, assembled the West Virginia Turnpike Commission to build a superhighway through West Virginia. With Paterson are, from left to right, West Virginia attorney general Ira J. Partlow, William G. Stathers of Clarksburg, D. Holmes Morton of Charleston, state road commissioner Ray Cavendish (ex officio member of the commission), Edward J. Flaccus of Wheeling, and Frank S. Easley of Bluefield. (Courtesy of the West Virginia Parkways Authority.)

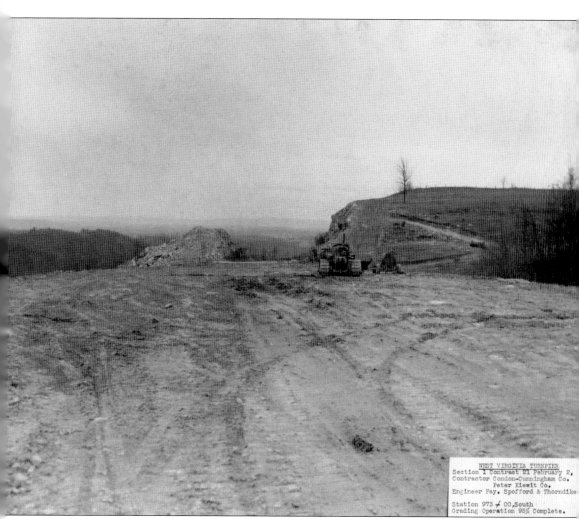

WEST VIRGINIA TURNPIKE
Section 1 Contract 21 February 2,
Contractor Condon-Cunningham Co.
Peter Kiewit Co.
Engineer Pay. Spofford & Thorndike

Station 973 + 00,South
Grading Operation 95% Complete.

The task was anything but easy for the gentlemen pictured on the previous page. The road ahead for this commission featured many twists and turns. The original plan was to build the turnpike from Wheeling to Princeton, but that plan was soon abandoned due to cost estimates, and the commission revised the turnpike to run from Charleston to Princeton. At the time, the 107-mile trip from Princeton to Charleston, mostly on US Route 21, featured steep grades, hazardous turns, and about four hours of travel time under good conditions. (Courtesy of the West Virginia Parkways Authority.)

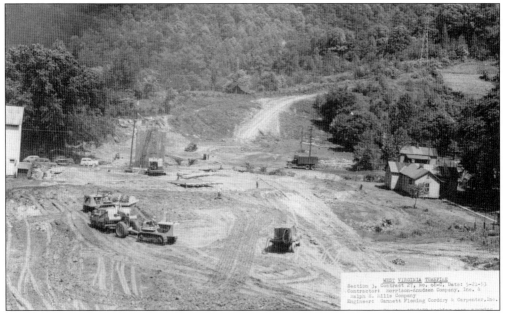

The groundbreaking ceremony for the turnpike took place on August 29, 1952, and construction of the West Virginia Turnpike involved the movement of an estimated 100 million cubic yards of earth, sandstone, and shale. The turnpike's original plans called for the construction of a four-lane highway, but that proved too costly. Even with adjustments, the project remained challenging at every twist and turn. (Courtesy of the West Virginia Parkways Authority.)

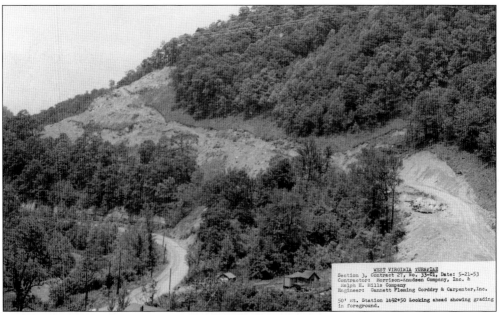

The 88-mile course of the West Virginia Turnpike starts at an elevation 600 feet above sea level in Charleston and goes to a height of 3,400 feet above sea level at the peak of Flat Top Mountain near the Raleigh-Mercer county line. Achieving the construction of a highway with gentle mount climbs and dissents was one of the biggest challenges faced by highway engineers as well as road construction crews. (Courtesy of the West Virginia Parkways Authority.)

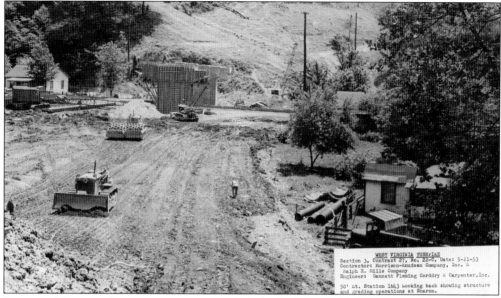

WEST VIRGINIA TURNPIKE
Section 3, Contract 27, No. 22-C, Date: 5-21-53
Contractor: Morrison-Knudsen Company, Inc. &
Ralph E. Mills Company
Engineer: Gannett Fleming Corddry & Carpenter, Inc.
50' Lt. Station 1643 looking back showing structure
and grading operations at Sharon.

Because of the irregular terrain, engineers included a total of 76 bridges along the 88-mile journey. The number of bridges increased to a new total of 116 when the turnpike became a four-lane highway. The coordination of small and large bridges on a highway built on irregular mountain slopes added challenges to design engineers and road builders alike. The engineers designed a highway with inclines of only three to five percent throughout its 88-mile course. (Courtesy of the West Virginia Parkways Authority.)

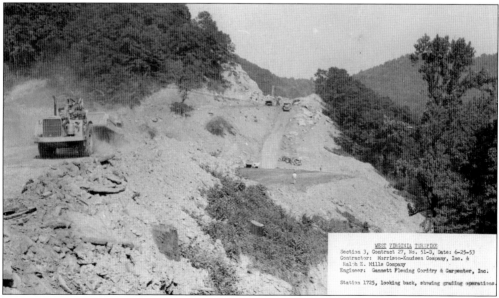

WEST VIRGINIA TURNPIKE
Section 3, Contract 27, No. 51-D, Date: 6-25-53
Contractor: Morrison-Knudsen Company, Inc. &
Ralph E. Mills Company
Engineer: Gannett Fleming Corddry & Carpenter, Inc.

Station 1725, looking back, showing grading operations.

Even during construction on the turnpike, engineers and laborers were aware of the unsurpassed beauty of the mountains that surrounded them. Engineers designed a highway that is nearly a straight line from Charleston to Princeton, and the incredible vistas that envelop the 88-mile course are incredible. Like any other highway, the West Virginia Turnpike had a utilitarian purpose. But in reality, the state created a road that can be at once pleasing to drive but also pleasing to experience. (Courtesy of the West Virginia Parkways Authority.)

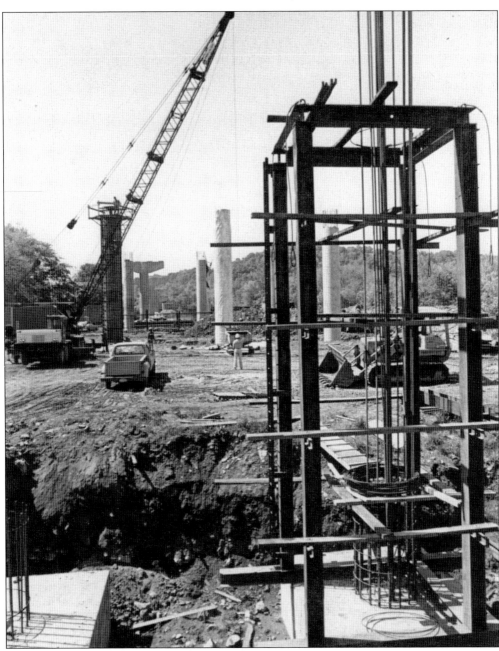

The turnpike commission selected the engineering firm of Howard, Needles, Tammen & Burgendoff (HNTB) of Kansas City, Missouri, to engineer the complex West Virginia Turnpike project. HNTB was founded in Kansas City in 1907 and continues to be one of the nation's most highly respected and trusted design firms. In 2015, the firm was ranked third in the nation's top 10 Most Innovative Companies and continues to provide incredible projects, including Levi's Stadium, home of the San Francisco 49ers; the Wichita Dwight D. Eisenhower Airport Terminal; Kroger Field at the University of Kentucky; the new New York Bridge project that replaces the Tappan Zee Bridge over the Hudson River; and also a wealth of other exciting projects. (Courtesy of the West Virginia Parkways Authority.)

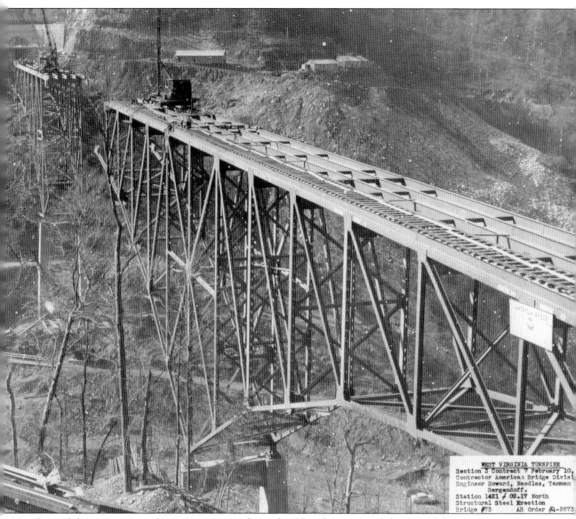

One of the most magnificent structures along the 88-mile course of the West Virginia Turnpike was the incredible Memorial Tunnel/Stanley Bender Bridge complex. The Memorial Tunnel alone cost $5 million to build. The structure through Paint Mountain was built in honor of all those who served or were then serving in the US military. The south portal of the Memorial Tunnel features the Stanley Bender Bridge. At the time it was built, the Bender Bridge was 278 feet above the valley floor and was the highest bridge east of the Mississippi River. The bridge was named in honor of US Army staff sergeant Stanley Bender, a native of Scarboro who received the Medal of Honor for gallantry above and beyond the call of duty near La Londe-les-Maures, France. (Courtesy of the West Virginia Parkways Authority.)

From conception through construction and completion, the West Virginia Turnpike made news as journalists nationwide searched the West Virginia hills for the latest scoop. John O'Brien of the *Detroit Times* said that the builders "literally moved mountains," and Edwin L. Beck of the *Commercial and Financial Chronicle of New York* claimed that highway students proclaimed the West Virginia Turnpike "a Mecca for tourists." (Courtesy of the West Virginia Parkways Authority.)

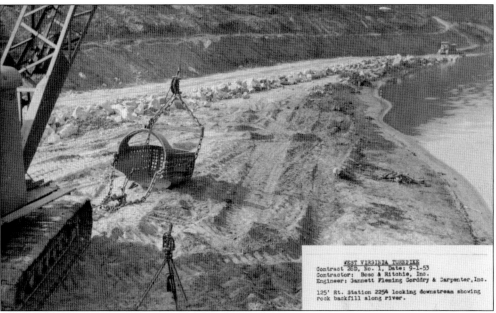

Highway construction workers needed to tread lightly as they carved back the mountainside to make room for the West Virginia Turnpike beside the Kanawha River. The turnpike commission had to scrap its initial plan to create a four-lane superhighway from Charleston to Princeton after traffic surveys revealed that projected traffic amounts did not warrant the construction of a four-lane expressway. (Courtesy of the West Virginia Parkways Authority.)

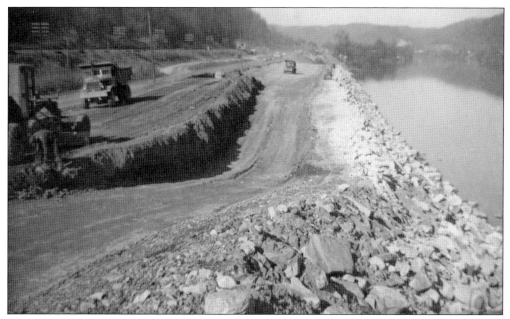

The turnpike commission resolved the issue by moving forward with a two-lane highway with the expectation of expanding the project to a four-lane highway as traffic warranted the expansion. As a result, the plan for the superhighway was never off the table but was rather in a holding pattern until such time that both the traffic count as well as federal initiatives to create a nationwide interstate highway system were present. (Courtesy of the West Virginia Parkways Authority.)

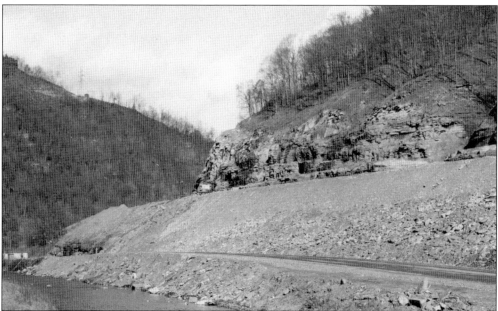

The early-1950s Chevy shown in the foreground of this photograph appears to be anxious to enter the highway. Construction crews used more than 16 million pounds of dynamite to blast through 60 percent of solid rock during construction of the highway. Crews moved more than 33 million cubic yards of limestone, shale, and earth to make way for the new highway. (Courtesy of the West Virginia Parkways Authority.)

While many states nationwide were debating the feasibility and merits of a full-blown national interstate highway program, the West Virginia Turnpike Commission pushed onward with its initial two lanes. Construction engineers used more than 200 different machines, like the bulldozer shown here, to clear a path through the unforgiving terrain. The process of cutting a pathway through the mountains was a monumental undertaking. (Courtesy of the West Virginia Parkways Authority.)

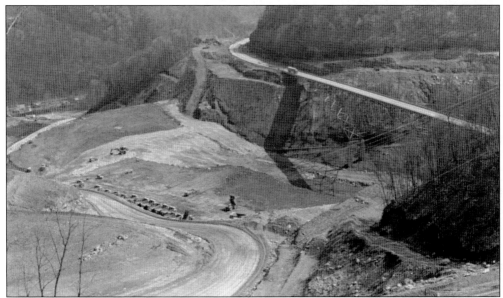

The magnificent Bender Bridge represented a breathtaking view of Paint Creek valley, located 278 feet beneath the southern portal of the Memorial Tunnel. Tractor trailer drivers who traveled the turnpike during the early days were impressed by the gentle curves and uniform grades that were mostly three percent with a couple five percent grades. Owen Deatrick of the *Detroit Free Press* wrote, "Objectors will turn into the foremost boosters when once they take a ride on the completed road." (Courtesy of the West Virginia Parkways Authority.)

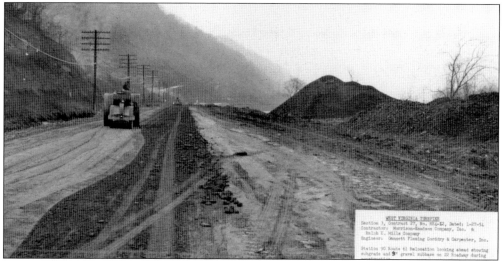

One of the lesser-known design features on the West Virginia Turnpike relates to the line of sight requirements throughout the 88-mile course. Design specifications for the project required the road builders to provide an unobstructed view of at least 600 feet. The requirement was most likely a novelty in the mid-1950s, but modern interstate construction projects include similar line of sight requirements as a part of their safety components. (Courtesy of the West Virginia Parkways Authority.)

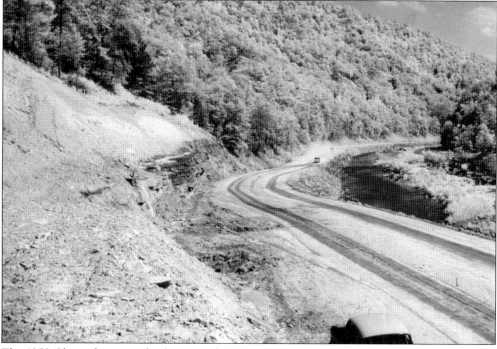

The 1950 Chevy shown in the foreground of this photograph appears to be poised and ready to take to the road as soon as the oncoming dump trucks pass. Mountainside control of both stone and vegetation has always drawn the attention of the West Virginia Parkways Authority. While crews address mountainside maintenance projects from spring through fall, maintenance crews are ready to respond to potential natural hazards year-round. (Courtesy of the West Virginia Parkways Authority.)

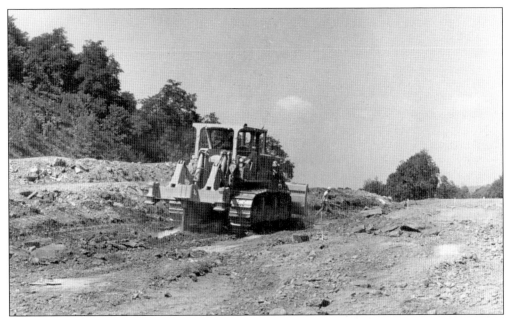

In order to attain the precision levels necessary to construct a project built with such exacting standards, skilled heavy equipment operators, like the one pictured here, worked closely with surveyors on foot who sited the progress in real time. Road builders who created the West Virginia Turnpike used modern earthmoving equipment, along with millennium-old measuring skills, to create a modern highway. (Courtesy of the West Virginia Parkways Authority.)

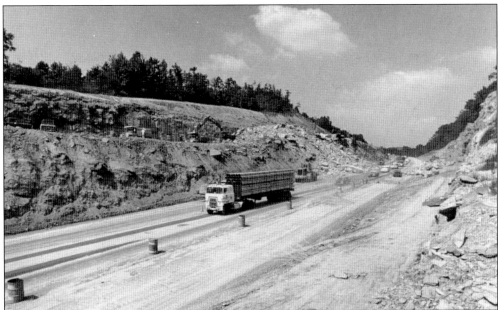

North and southbound commercial traffic has been one of the steadiest customers of the West Virginia Turnpike since its opening. Designers had truckers in mind when they included "creeper lanes" to assist automobile traffic flow as heavy haulers geared down when ascending grades. Division of highways road builders still use the extra lanes, often called "climbing lanes," on mountainous secondary highways where possible. (Courtesy of the West Virginia Parkways Authority.)

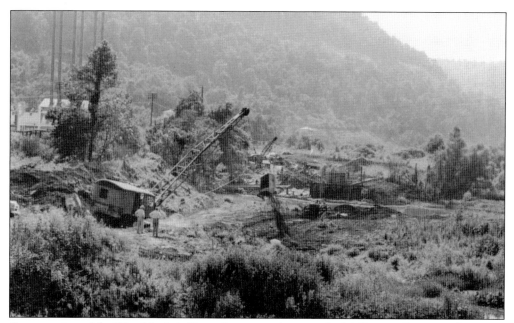

Construction of the West Virginia Turnpike required a myriad of skills as well as a goodly variety of heavy equipment. Here, a steam shovel is shown digging into the moist soil on the banks of Slaughter's Creek in search of bedrock to anchor bridge pilings. The combined expertise of the design engineers, surveyors, and construction personnel built a highway through one of the most challenging terrains in the eastern United States. (Courtesy of the West Virginia Parkways Authority.)

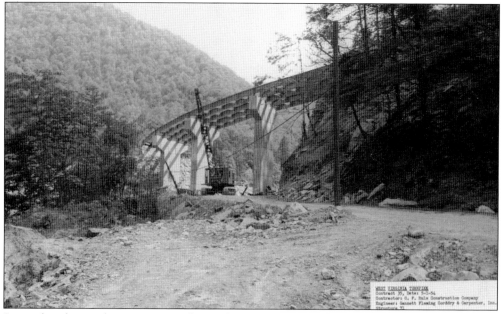

Steam shovels served many purposes during the construction of the West Virginia Turnpike. Here, a boom works to assist in the completion of a bridge project on May 1, 1954. It seems hard to believe that the southernmost section of the turnpike would open to travelers on September 2, 1954, just four months after this photograph was taken. The entire turnpike opened on November 8, 1954. (Courtesy of the West Virginia Parkways Authority.)

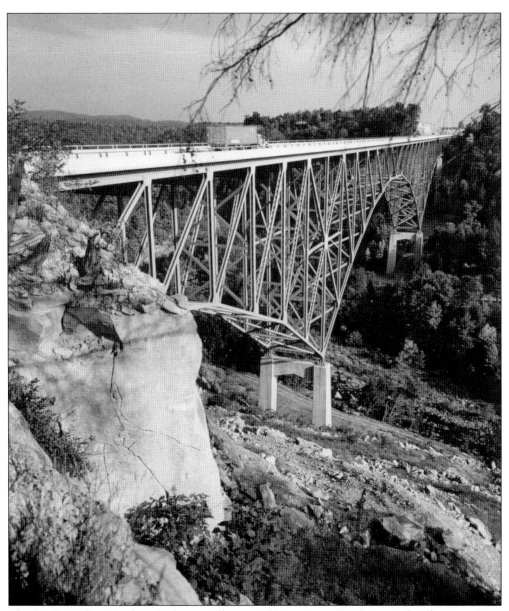

The Sgt. Cornelius Charlton Bridge over Bluestone Gorge towers 238 feet over the Bluestone River below. Sergeant Carlton was a native of East Gulf, Kanawha County. In 1944, he and his family moved to the Bronx, New York, where he was living when he joined the US Army in 1946. For his service and sacrifice during the Korean War, he received the Medal of Honor while serving with Company C of the 24th Infantry Regiment, 25th Infantry Division. The 24th Infantry Regiment was the last all-African American regiment in the US Army at the time. On June 2, 1951, near the village of Chipo-ri, Sergeant Charlton participated in three charges upon a heavily fortified position—leading the final two charges—when he was wounded during each one. During the final attack, Charlton disabled the last remaining gun placement but died as a result of the wounds he received that day. He was 21 years old. While he grew up and graduated from high school in New York, the West Virginia Turnpike Commission sought to honor Sergeant Charlton by naming the bridge in his honor. (Courtesy of the West Virginia Parkways Authority.)

Three

BUILDING A SUPERHIGHWAY

The West Virginia State Police Turnpike Division has been serving motorists since the traffic started rolling on the highway in 1954. Troop No. 7 of the West Virginia State Police has roster space for 31 troopers, but the average number serving is about 28, according to Jeff Miller, turnpike authority administrator. The force includes 26 troopers now, with two currently on active deployment with the military. Troop No. 7 is based in Beckley but maintains offices in Charleston and Princeton. (Courtesy of the West Virginia Parkways Authority.)

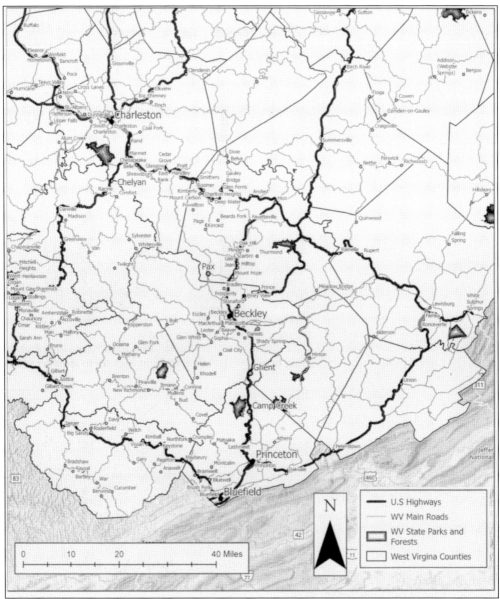

This enhanced excerpt from a 1948 highway map distributed by the state road commission shows a dramatic difference in travel opportunities through south-central West Virginia. US Route 19/21 from Bluefield to Princeton and Beckley faced mountain challenges similar to the ones the West Virginia Turnpike designers faced, but prior to the erection of the New River Gorge Bridge that was completed on October 22, 1977, travel through the gorge was challenging. Traveling Route 16 from Beckley to Pax or Route 3 to Whitesville made for a long trip as well. The engineers with Howard, Needles, Tammen & Burgendoff (HNTB) based the plan of the turnpike on a straight line from Beckley to Charleston. The current West Virginia Turnpike Authority still has a working relationship with the Kansas City, Missouri, firm. (Courtesy of the West Virginia Parkways Authority.)

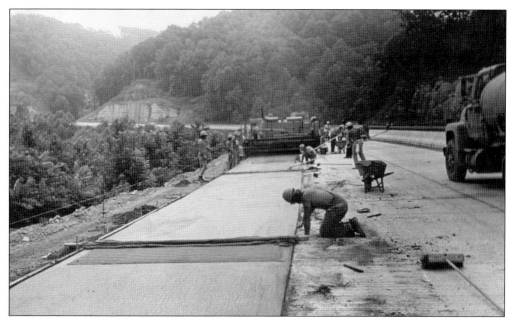

After creating a level surface for the turnpike, cement finishers erected a crushed stone base 14 inches thick with a one-inch cushion of sand and topped them with a nine-inch deep base of Portland cement concrete. In most instances, the substructure of the highway roadbed remained intact. In 2009, the turnpike authority began using heavy overlays that are built back up to anywhere from 5 to 10 inches of asphalt. (Courtesy of the West Virginia Parkways Authority.)

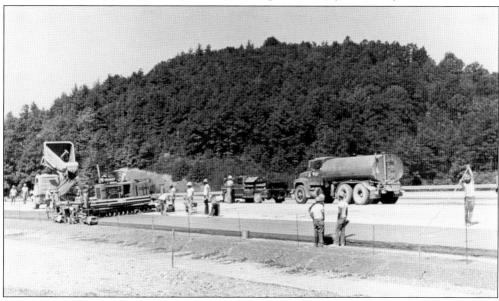

The substructure of the road remains original through most of the superhighway, but when the West Virginia Parkways Authority undertook the Beckley expansion project in 2017, which widened the turnpike from four lanes to six lanes to accommodate the additional traffic flow, highway engineers transformed the base to full rubberization. Road builders break up the existing concrete slabs and put a free drain base asphalt down. Additional asphalt layers bring the road surface up to the appropriate grade. (Courtesy of the West Virginia Parkways Authority.)

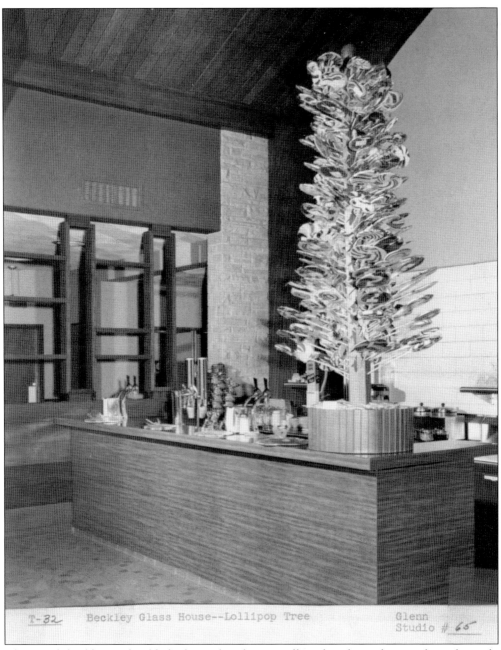

T-32 Beckley Glass House--Lollipop Tree Glenn
 Studio # 65

Along with building a durable highway that dramatically reduced travel times through south-central West Virginia, the turnpike designers sought to make the comfort stops as enjoyable as the drive itself. The Lollipop Tree at the fountain of the Beckley Glass House was a fun attraction for travelers as well as local residents, who came to experience some of the avant-garde attractions at the original three stops on the 88-mile journey. Each of the three glass house comfort stops evolved through the years to meet the needs of an ever-changing traveling public. While the experience of driving through the breathtaking West Virginia mountain scenery was an attraction in its own rite, the Bluestone, Beckley, and Morton rest stops each featured a unique glimpse into the people of south-central West Virginia. (Courtesy of the West Virginia Parkways Authority.)

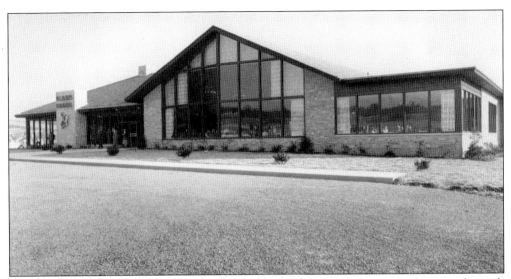

The Beckley Glass House was located on the southbound side of the turnpike about a mile north of Harper Road Exit 44. There was no access to the Beckley site for northbound travelers, but those who chose to do so could travel a few miles to Exit 48, US Route 19 North, and circle back to the glass house. While that might appear inconvenient, the glass house restaurants were local attractions. (Courtesy of the West Virginia Parkways Authority.)

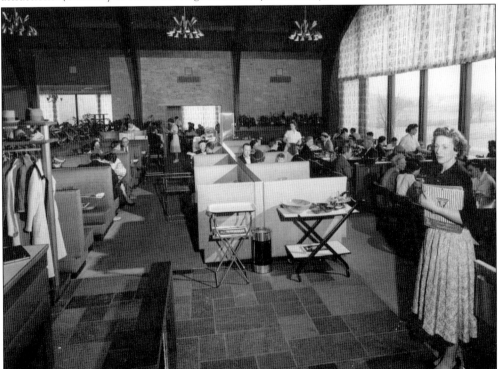

The 1955 vintage modern appearance of the Beckley Glass House was a welcome sight for travelers and locals alike. The restaurants featured good food, great service, and air-conditioned comfort. Glass house restaurants date back to as early as 1940 in Boyette, Florida, and became a popular restaurant chain along toll roads throughout the south. (Courtesy of the West Virginia Parkways Authority.)

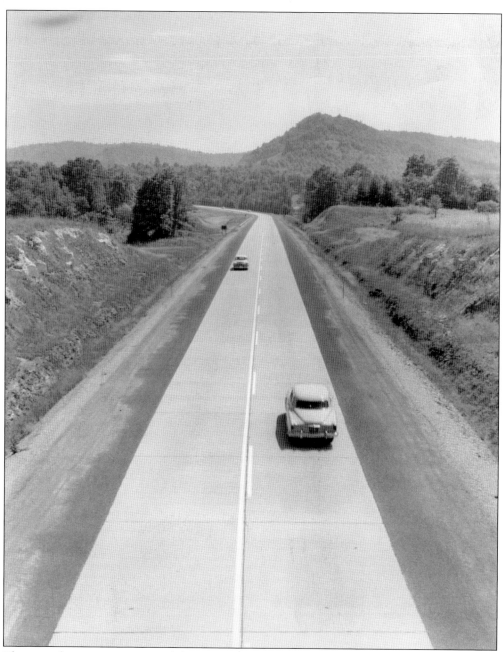

The turnpike commission started the process of building the West Virginia Turnpike as close as possible to a straight line between Princeton and Charleston, West Virginia. This short stretch of the turnpike in Raleigh County was almost a straight line. However, mountains, valleys, rivers, creeks, and streams contributed to a myriad of challenges for both engineers and building contractors. Still, for a state that has become known worldwide for its county roads, thanks to the Bill Danoff, Taffy Nivert, and John Denver song, "Take Me Home, Country Roads" (1971) that celebrates West Virginia's comforting, friendly mountains and people, the West Virginia Turnpike opened a conduit for travelers to enjoy the heart of the Mountain State. (Courtesy of the West Virginia Parkways Authority.)

The Bluestone Travel Plaza—also a glass house—served as a welcome center to West Virginia for many years. The service center is located less than a mile away from the Bluestone Gorge, a site with valley walls so steep that there is no commercial development along the Bluestone River for more than roughly 20 miles. Intrepid fly fishermen as well as nature-loving hikers enjoy the isolated Bluestone River, West Virginia's only "wild and scenic river," as it was called in the November 8, 1954, dedication program. (Courtesy of West Virginia Parkways Authority.)

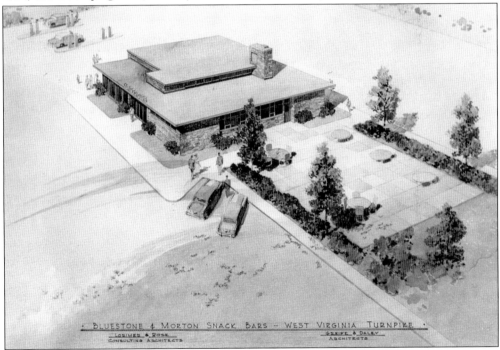

The Bluestone Travel Plaza has a twin about 55 miles north in the Morton Service Center, shown here in an architectural drawing. Where Bluestone is located near the top of a mountain, Morton is located in a deep valley that was carved out by Paint Creek over centuries. Historians believe that the creek earned its name from trees marked with red hues by First Nations people to indicate a footpath. First Nations people were also known to twist or bend forest saplings to indicate safe trails. Foresters often encounter these trail markings in the mountains. (Courtesy of the West Virginia Parkways Authority.)

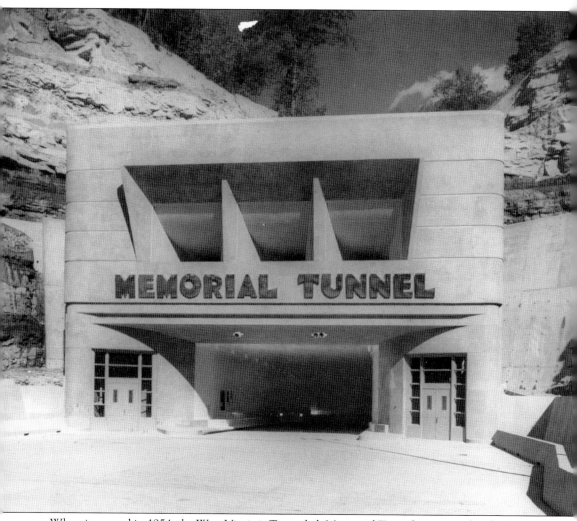

When it opened in 1954, the West Virginia Turnpike's Memorial Tunnel was considered to be one of the engineering marvels of the 88-mile superhighway. Throughout its history, West Virginians have answered the call to military service at the highest per capita percentage in the nation. In recognition of this personal commitment to all branches of the military, the turnpike named the tunnel in honor of all those West Virginians who had served or are serving in the military. The approximately $5 million cost of the project may have had an impact on the decision to build a two-lane rather than a four-lane superhighway as originally planned. (Courtesy of the West Virginia Parkways Authority.)

When northbound motorists approached the Memorial Tunnel from the south, they encountered Paint Creek before coming to Bender Bridge at the southern tunnel portal. For drivers who had grown accustomed to driving the country roads that wound their way through the mountains, the turnpike was an awe-inspiring experience. Safety features inside the Memorial Tunnel included 24-hour television surveillance cameras and monitors. (Courtesy of the West Virginia Parkways Authority.)

Southbound traffic entering the northern portal of the Memorial Tunnel were comforted by the knowledge that the tunnel's state-of-the-art ventilation system ensured that fresh air was always moving in the tunnel and exhaust fans were removing the exhaust from cars and trucks. The tunnel also had fire extinguishers as well as water hydrants in case of a vehicle or truck fire inside. Pamphlets produced when the turnpike opened declared the experience to be "a magic carpet ride through a beautiful land." (Courtesy of the West Virginia Parkways Authority.)

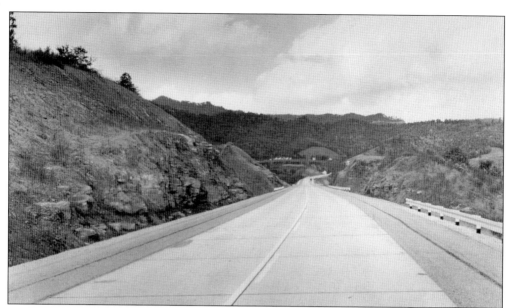

Most first-time travelers on the West Virginia Turnpike got to see parts of the state they never knew existed. The Pax community, shown here, was likely named for nearby Packs Branch Creek. The Pax tollbooth and nearby exit is located at mile marker 54. According to Wikipedia, the community's most-famous native son is Walter Anderson Craddock, a southpaw pitcher for the Kansas City Athletics in 1955–1956 and 1958. He saw action in 29 major-league games. The turnpike opened just in time for him to make it to the big leagues. (Courtesy of the West Virginia Parkways Authority.)

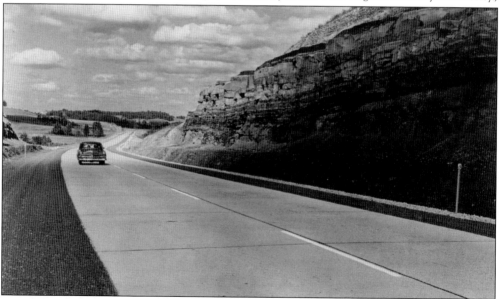

The Ghent community is near the pinnacle of Flat Top Mountain. During the American Civil War, the 23rd Ohio Volunteer Infantry camped near the summit of Flat Top and launched an attack on Confederate-held Princeton in early May 1862. After securing Princeton, the 23rd Ohio traveled to Giles Courthouse in Pearisburg, Virginia. Sgt. William McKinley was wounded in the battle at Giles Courthouse and was transported back to Princeton's McNutt House. (Courtesy of West Virginia Parkways Authority.)

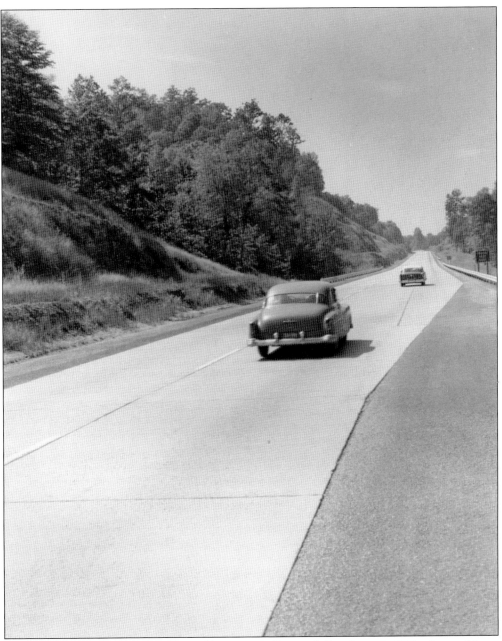

The uphill climb to Sullivan Road in Beckley was a challenging hill in the early 1950s when architects put together the turnpike from Beaver to Beckley in Raleigh County. Although climbing lanes through mountainous terrain were not a novel idea when HNTB designed the turnpike, meeting the 600-foot line of sight and the sub-10-percent grade requirements of the contract created an opportunity for creative highway placement. As a result, the creeper lanes, as they were called at that time, featured a gentle slope and mostly unencumbered line of sight for motorists traveling at 60 miles per hour—the speed that the turnpike commission recommended when the highway was first conceived. (Courtesy of the West Virginia Parkways Authority.)

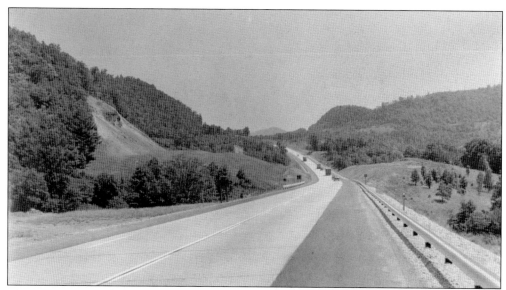

The southernmost starting point was Princeton. When the turnpike opened, there was a small on-ramp tollbooth in Mercer County, and the first several miles of the journey were through rolling farmlands, like what are shown in this photograph near mile marker 10. Prior to the coming of the West Virginia Turnpike, Princeton had been a key crossroads for US Route 19 and US Route 21. Princeton was established as the county seat when the Commonwealth of Virginia created Mercer County in 1837. The town grew in 1909 when the Virginian Railway located its mechanical shops there, but the turnpike brought even greater growth. (Courtesy of the West Virginia Parkways Authority.)

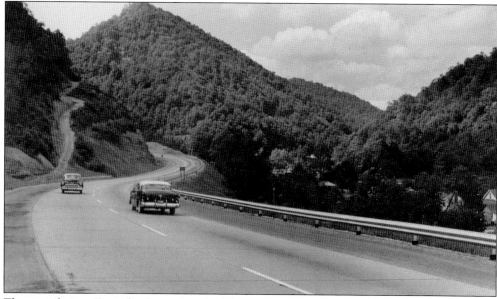

The turnpike into Kanawha County north of the Morton Service Center was lower than a 10-percent grade, but because of the length of the climb, it often resulted in slow-moving truck traffic. Still, the changing seasons from summer to fall and winter to spring gave frequent travelers ever-changing scenery year-round. While the visionary members of the turnpike commission had dreamed that the highway would be a straight line, the mountains, curves, and changing foliage enhanced the driving experience. (Courtesy of the West Virginia Parkways Authority.)

The rolling hills of Mercer County take on even greater beauty when an early snow and frost transform the area into a winter wonderland. In the 21st century, a news of osprey nested in the cliff at left in the photograph above, but they recently took flight and took up residence somewhere else. Still, the thrill of seeing an osprey take flight and soar above lakes and ponds in the region was exciting. Bird-watchers frequently observe bald eagles and a myriad of hawk species that migrate in the fall along the spine of the Appalachian Mountains. (Courtesy of the West Virginia Parkways Authority.)

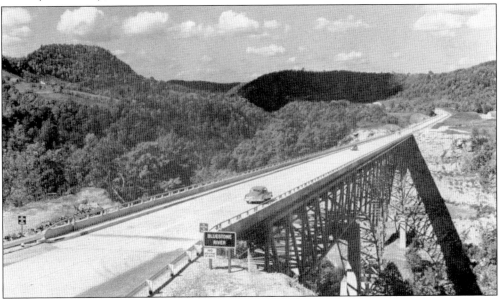

On September 2, 1954, the Charlton Memorial Bridge over the Bluestone Gorge was dedicated in honor of Sgt. Cornelius Charlton, who received the Medal of Honor for gallantry and service beyond the call of duty for his selfless heroism during the Korean War. Sergeant Charlton died as a result of hostile fire on June 2, 1951. After his remains were returned to the United States, he was buried at the Bryant Memorial Cemetery in Mercer County. (Courtesy of the West Virginia Parkways Authority.)

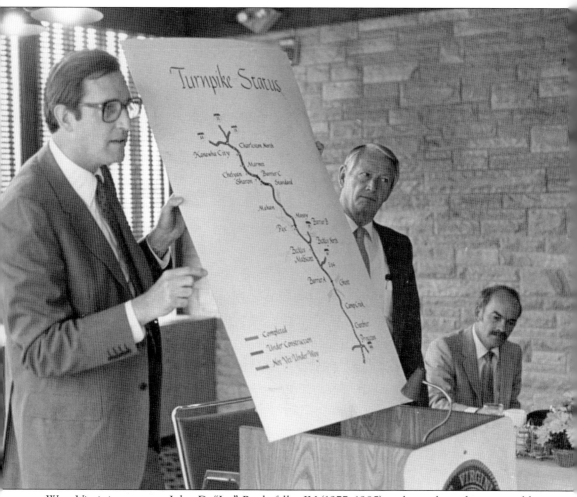

West Virginia governor John D. "Jay" Rockefeller IV (1977–1985) is shown here during a public briefing concerning turnpike matters of importance. During his tenure, the highway experienced significant growth in terms of traffic counts and appreciation. In the 1950s, Pres. Dwight D. Eisenhower had viewed the importance of a modern highway system in terms of national defense, but the potential for using toll roads to stimulate economic growth brought on fears of another depression. On May 29, 1956, Congress passed the Federal Highway Act of 1956, which created a Highway Trust Fund that was supported by a one penny increase in the federal tax on gas and diesel fuel and raised the per-gallon tax from 2¢ to 3¢. On November 14, 1956, a few officials gathered for a ceremony in Topeka, Kansas, to open the first eight miles of the federal Interstate Highway System. With a system of financial support in place, the Interstate Highway System was born. (Courtesy of the West Virginia Parkways Authority.)

Four

INCLUSION OF THE US INTERSTATE HIGHWAY SYSTEM

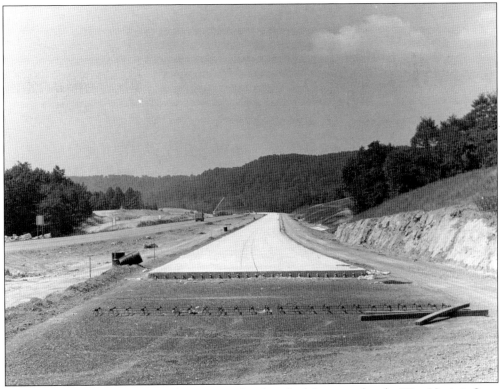

After the dualization (expansion from two to four lanes) of the turnpike, the West Virginia State Legislature dissolved its commission and established the West Virginia Turnpike Economic Development and Tourism Authority in 1989. Completing the additional two lanes of the 1954 turnpike design enabled the turnpike to connect with Interstate 64 in Charleston and to unite Interstate 79 in Charleston to Interstate 77 in Princeton. With Interstate 64 and Interstate 77 running together from Charleston to Beckley, the turnpike became an important north-south and west-east crossroads. (Courtesy of the West Virginia Parkways Authority.)

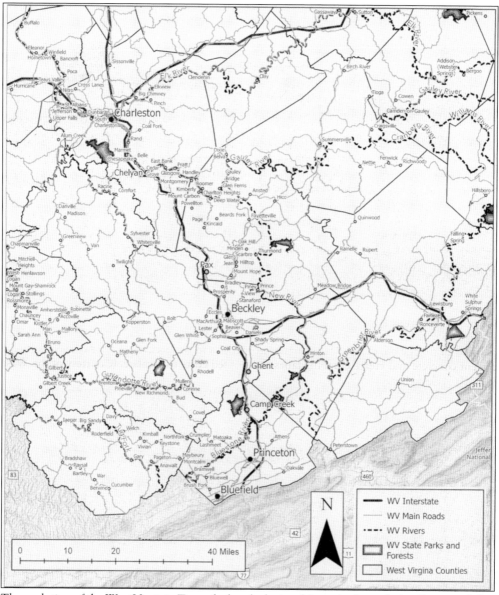

The evolution of the West Virginia Turnpike barely deviated from the "straight line" proposal that guided the turnpike commission in the late 1940s and followed through over nearly a half-century. That straight line extends from Charleston to Princeton—the site of the southernmost tollbooth in the early years—with Interstate 77 jogging slightly northeast from Bluefield to Princeton. From start to finish, the West Virginia Turnpike was an engineering feat, but unlike the Federal Highway Act, which was funded through a portion of the federal tax on gasoline and diesel fuel, West Virginia's turnpike was funded through a series of bonds. The firms of Bear Stearns & Company and Byrne & Phelps provided risk capital and financing for the project. Bonds in the amount of $96 million were issued in April 1952, and construction began on September 1, 1952. (Courtesy of the West Virginia Parkways Authority.)

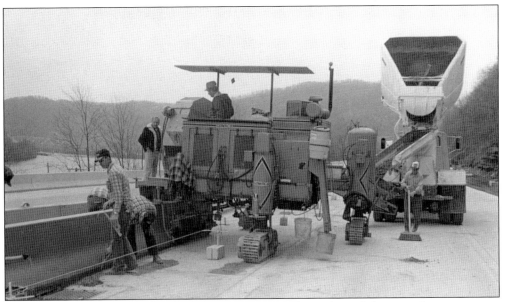

The realities of mountain highway construction constantly confronted the turnpike commission. In 1954, it was necessary for the commission to float an additional $37 million bond due to unforeseen problems related to preparing the additional two lanes for future construction. The cost of determining the oil, gas, and coal surface properties and the decision to use high-end Portland cement concrete and create climbing lanes also caused costs to escalate. (Courtesy of the West Virginia Parkways Authority.)

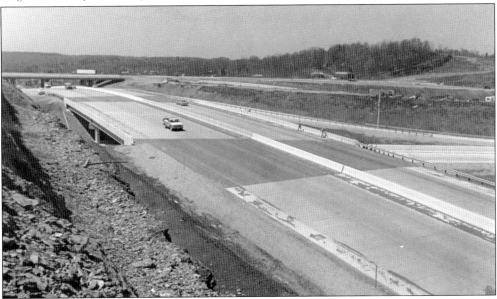

The beauty of four-lane interstate highways is that motorists who master one regional interstate can easily adapt to the flow of traffic in another part of the country. While turnpikes generate revenues, they follow the same basic design from Maine to Arizona and from Oregon to Florida. During construction, interchanges like the one here at Charleston appear similar, but commercial and residential centers develop so quickly at an exit, that it is difficult to identify a site when it is being built. (Courtesy of the West Virginia Parkways Authority.)

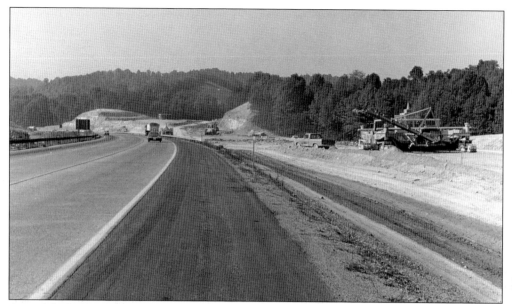

One of the busiest intersections on the turnpike is the Interstate 77/Interstate 64 interchange at mile marker 38, shown here under construction. During construction, motorists found it difficult to understand how the configuration of the separation of the north-south and east-west interstates could have been configured. However, traffic continued to travel on the turnpike as construction was underway, and Gov. Arch Moore hosted a huge crowd when he cut the ribbon to open the new interchange. (Courtesy of the West Virginia Parkways Authority.)

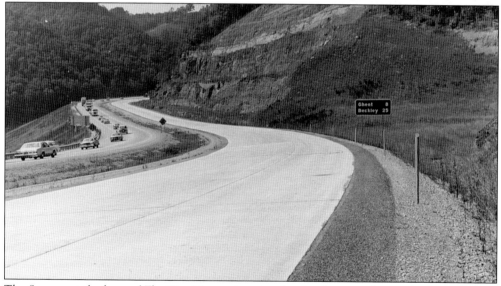

The S curve at the base of Flat Top Mountain proved to be the site of many fatal accidents in spite of several warning signs cautioning truckers and tourists to slow their vehicles starting at the mountaintop and continuing down to the base. The highway was properly engineered, and snow and ice removal crews based at the top of the mountain kept the interstate free of snow and ice, but tragedy struck in more recent years. The West Virginia State Police and state commerce commission have clamped down on excessive speeds and faulty commercial equipment. (Courtesy of the West Virginia Parkways Authority.)

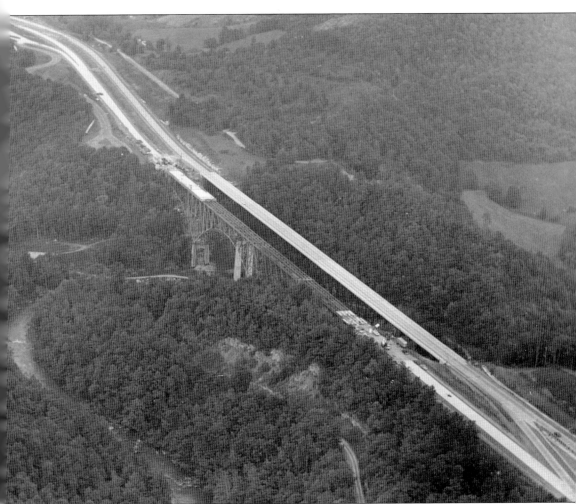

One major engineering hurdle in the construction project that enabled the West Virginia Turnpike to become part of the federal Interstate Highway System was erecting a new Sgt. Cornelius Charlton Bridge over the Bluestone Gorge for southbound traffic. Unlike the Bender Bridge, the Charlton Bridge required the complete construction of a duplicate bridge over the Bluestone River, which was 238 feet below the bridge surface. Easements and property purchases were completed during the initial construction phase in the 1950s, but a duplicate span over challenging terrain represented an incredible task. The Bryant Memorial Cemetery where Sergeant Charlton's remains were initially did not have perpetual care. As a result, like many African American cemeteries in southern West Virginia, it became overgrown. In the early 1990s, Charlton's remains were removed from Bryant Memorial Cemetery, and he was reinterred at the American Legion Cemetery in Beckley. In 2008—thanks to the enduring efforts of his descendants—his remains were buried at Arlington National Cemetery. (Courtesy of the West Virginia Parkways Authority.)

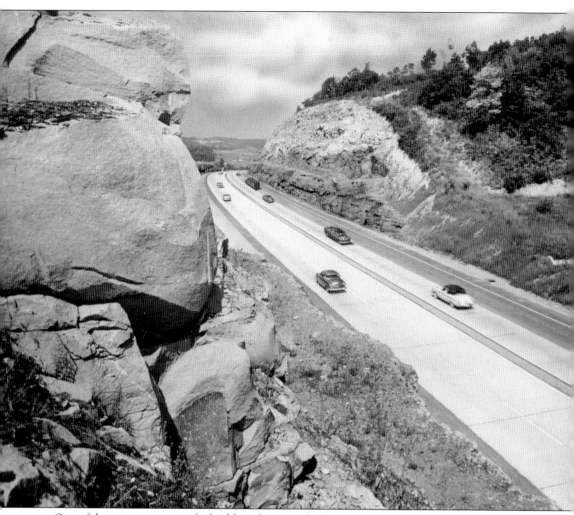

One of the primary reasons for building the turnpike from Princeton to Charleston was to connect the people of southern West Virginia with their state capital. A fringe benefit of the process was that the existence of a toll road gave small communities the opportunity to tie into the economic development juggernaut that the increased traffic brought. When the four-lane highway was completed, motorists not only got the opportunity to enjoy the ride on a smooth, safe highway, but also had the opportunity to experience the mountains from the inside out, as this photograph of a beautiful cut through solid rock illustrates. (Courtesy of the West Virginia Parkways Authority.)

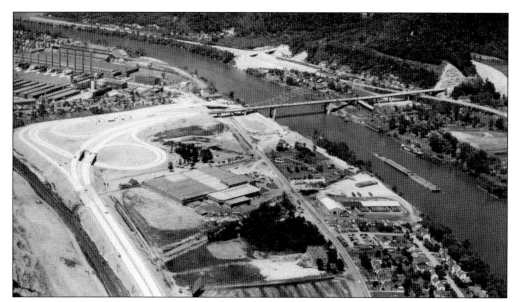

On October 14, 1947, then captain Charles E. "Chuck" Yeager became the first man to break the sound barrier. It took until June 1948 for news of the flight in a Bell X-1 rocket-powered aircraft to be released, and Yeager, born in Myra, West Virginia, and already an ace World War II combat pilot with 13 German planes destroyed, became a national hero. A little over two years later on October 25, 1949, the turnpike commission was established. The commission would later name the bridge that spans the Kanawha River between Charleston and Kanawha City in Yeager's honor. (Courtesy of the West Virginia Parkways Authority.)

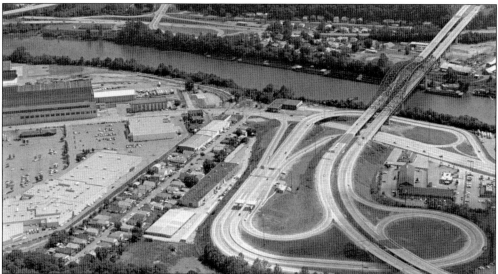

A key component necessary for bringing the turnpike up to federal Interstate Highway System standards was to add additional spans at Bluestone and Charleston. There is a singular beauty to the free-flowing entrance and exit ramps that enable nearly seamless ingress and egress to modern interstate highways that enhance safety for motorist. Gen. Chuck Yeager passed away on December 7, 2020. He served his nation and his state with unbridled dedication and stirs pride among West Virginians as they make note of his name on the West Virginia Turnpike bridge. (Courtesy of the West Virginia Parkways Authority.)

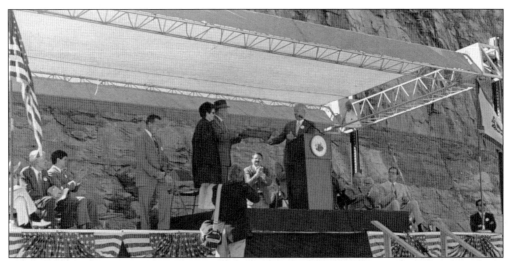

West Virginia governor Arch Moore is shown here presenting a sign to S.Sgt. Stanley Bender and his wife, Esther Marie, at the official opening of the completion of a 1.72-mile detour around the former Memorial Tunnel/Bender Bridge complex, which was completed in 1955. The project required moving enough fill material to raise the road to a height of 311 feet at a cost of almost $35 million. In all, 10 million cubic yards of earth were moved on the tunnel/bridge replacement project, which was completed in 1989. Bender, a native of Scarbro, received the Medal of Honor during World War II while leading an assault that resulted in destroying an enemy roadblock, taking a town, and seizing three bridges intact near La Lande, France. Staff Sergeant Bender died on June 22, 1994. (Courtesy of the West Virginia Parkways Authority.)

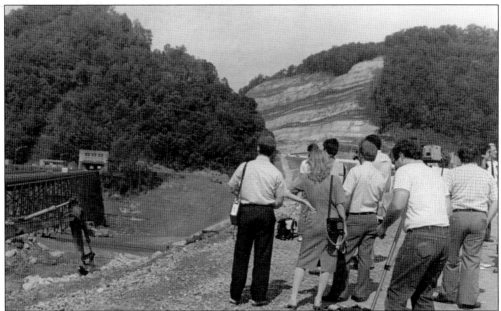

The turnpike deactivated its tollbooths for the ceremony honoring Staff Sergeant Bender, and not long afterwards, media gathered in mass to witness the historic demolition of the former Bender Bridge. While the original bridge was erected on a steel support system, the twin Bender Bridge complex has concrete pillars. The significance in the bypass opening was that the West Virginia Turnpike could be elevated to interstate standards. (Courtesy of the West Virginia Parkways Authority.)

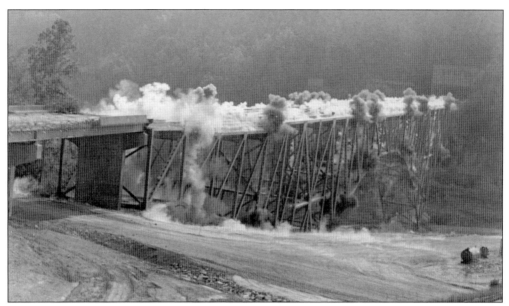

Demolition crew members set a series of charges on the bridge that once enabled traffic to cross the ravine that was created by Paint Creek over centuries. Photographers captured the sequence of blasts. The initial blast disconnected portions of the bridge from its anchors—one on the mountain side and the second on the northern side of the ravine near the southern mouth of the Memorial Tunnel. Soon after the first charges ignited, the second set of charges (shown above) ignited at the bridge-deck level across the entire span. (Courtesy of the West Virginia Parkways Authority.)

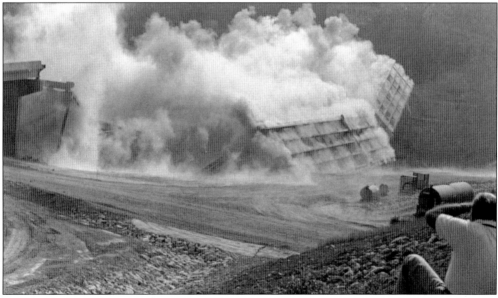

The third ignition (the initial puffs of smoke seen in the substructure of the bridge) ignited, and the entire span and support structure collapsed into Paint Creek at the bottom of the valley floor. The bridge's piers are now covered by the fill that raised the highway to 311 feet above the former Fourmile Creek streambed. The project to reroute traffic off the tunnel and bridge complex cost almost $35 million—approximately seven times the cost of the tunnel it replaced. (Courtesy of the West Virginia Parkways Authority.)

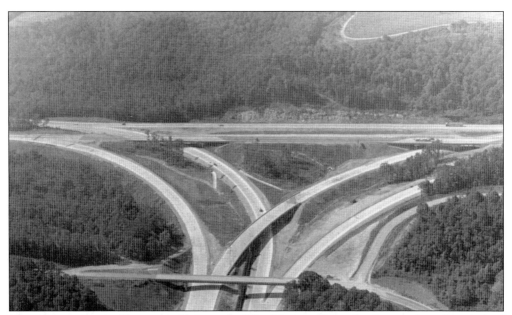

The eastbound exit of Interstate 64 from the West Virginia Turnpike about eight miles south of Beckley was one of the highlights of the modern era of travel through West Virginia. Interstate 64 through south-central West Virginia travels through beautiful mountain scenery with tourist sites, including Grandview State Park overlooking the majestic New River; Historic Lewisburg, recently recognized as the nation's "Coolest Small Town;" and the historic Greenbrier Hotel. (Courtesy of the West Virginia Parkways Authority.)

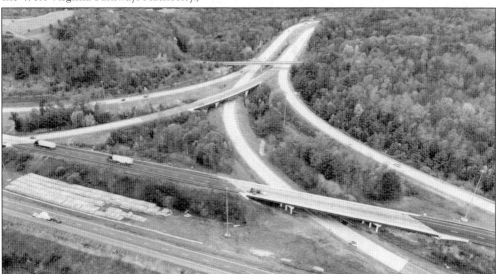

Interstate 64 East and the West Virginia Turnpike become one in Charleston and travel together until they part at mile marker 42. Upon entering Virginia, Interstate 64 connects with Interstate 81 north until it reaches Staunton, then heads all the way east to the Atlantic Ocean at Chesapeake, Virginia. The western terminus of Interstate 64 is at Wentzville, Missouri, where it merges into Interstate 70 West. The Interstate 64/Interstate 79 connection experiences heavy travel year-round but tends to have the most travel on holidays and during the summer months. (Courtesy of Randall Hash.)

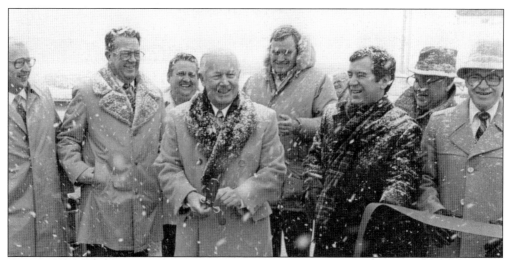

Gov. Arch Moore is shown here at the ribbon-cutting ceremony for the official opening of the Interstate 64, the Beckley Interchange. The event was part of Moore's "Across the State in '88" celebration that recognized the historic crossroads in the heart of south-central West Virginia. Former US representative Nick Rahall is shown here to the right of Governor Moore. After the two-interstate project was completed, the West Virginia State Legislature dissolved the turnpike commission and created the West Virginia Parkways Economic Development and Tourism Authority in 1989. Any reference to the West Virginia Parkways, Economic Development, and Tourism Authority within West Virginia Code Sec. 17-16A-3 shall mean West Virginia Parkways Authority. (Courtesy of the West Virginia Parkways Authority.)

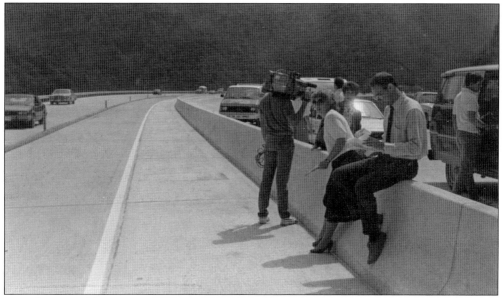

Since the topic of the west Virginia Turnpike was first discussed in 1947, almost every new development has been greeted by extensive press coverage. To be sure, the media routinely covers crashes, traffic backups, and delays as well as highway section openings of major interstate highways, but the West Virginia Turnpike seems to garner media coverage in both breaking news events and preplanned press conferences. West Virginians remain interested in things taking place on the turnpike. (Courtesy of the West Virginia Parkways Authority.)

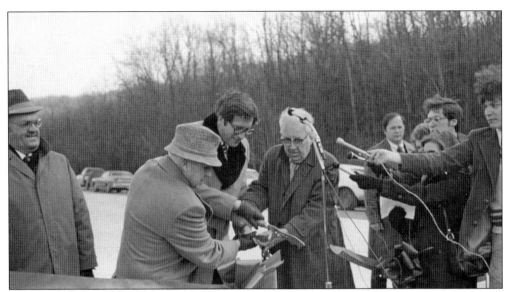

From left to right behind the microphone, V.B. Harris, former chairman of the turnpike commission; then governor John D. "Jay" Rockefeller IV; and former governor Okey L. Patterson, who served as governor during the construction and completion of the turnpike, are shown here cutting the ribbon for a major turnpike improvement project on July 15, 1988, as part of the "Across the State in '88" initiative. Through the years, leadership in Charleston has actively demonstrated unwavering support for the West Virginia Turnpike at every step forward in its progress. (Courtesy of the West Virginia Parkways Authority.)

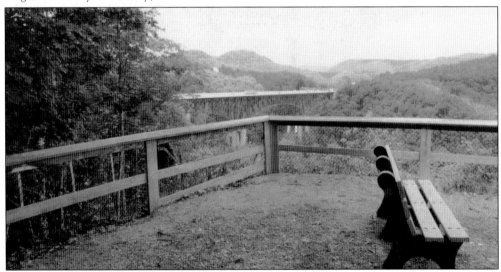

For those who enjoy solitude, the Nature Conservancy encourages travelers to take a break from the high-speed humdrum of the highway and visit the Bluestone Gorge Overlook. First Nations people of the region named the river that originated from three mountaintop springs in Tazewell County, Virginia. The three springs take different paths to reach the Ohio River. Eastward flowing waters travel on the Bluestone to the New River and, from there, connect with the Gauley River to form the Kanawha that joins the Ohio at Point Pleasant. Westward water from the divides form the Holston River that flows to Knoxville where it joins the French Broad River to form the Tennessee River, the Ohio River's largest tributary. (Photograph by the author.)

West Virginia governor Gaston Caperton is shown here being interviewed by Penny Moss and video journalist Mark Hughes of WVVA-TV following the announcement that the parkways authority was removing the side tolls from every exit except the Interstate 77 US Route 19 exit at North Beckley. Side tollbooths featured coin-toss baskets but were also staffed around the clock for people who did not have correct change. At first, travelers were charged on the basis of a ticket they received at the first tollbooth they entered and, upon exiting the turnpike, would pay cash for the number of miles they traveled. (Courtesy of the West Virginia Parkways Authority.)

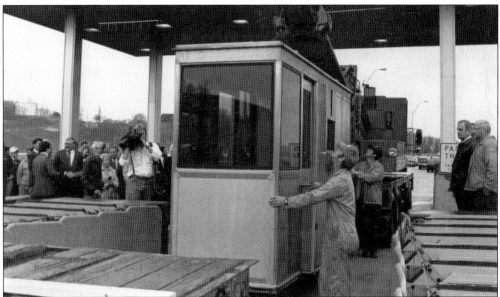

Side tollbooths were staffed at the Camp Creek, Gent, and Beckley exits. Like most other turnpike events, removal of the side tollbooths was a big deal. At first, travelers were charged on the basis of a ticket they received at the first tollbooth they entered. In the first few years, a passenger car could travel the entire turnpike for $1.50. Commercial truckers could acquire a swipe-style credit card that would bill the commercial operator. In the late 1980s, the West Virginia Parkways Authority introduced an E-ZPASS system to enable frequent users to receive periodic invoices for turnpike usage. Since 2015, West Virginia residents have been able to pay a flat annual fee for an E-ZPASS to enjoy unlimited use of the turnpike. (Courtesy of the West Virginia Parkways Authority.)

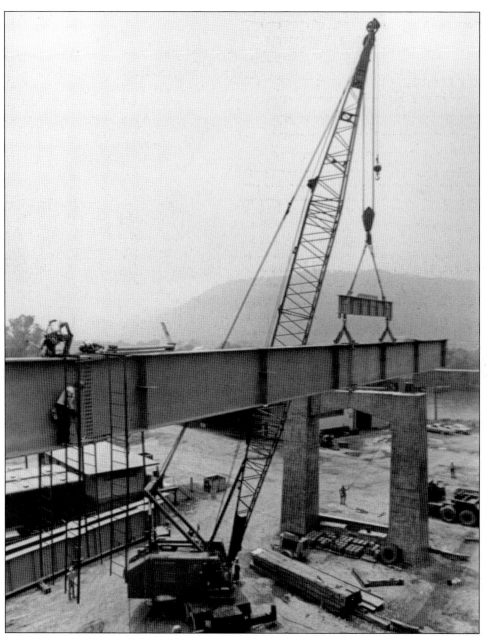

Construction of the combined Interstate 64/Interstate 77 corridor enabled the West Virginia Parkways Authority to issue short-term notes for construction projects. As a result, the West Virginia Department of Highways was able to have all of the remaining projects on the turnpike under contract by 1984. In addition, about half of the projects on Interstate 64 could be under contract by the spring of 1984. West Virginia used federal funds available through the federal Surface Transportation Act of 1982. The opportunity to mingle state and federal funds on projects where Interstate 64 and Interstate 77 were combined created an incredible transformation in terms of progress of some major projects that benefitted travelers. What had previously been a time-consuming, dusty trail through a complex construction project became a superhighway in a matter of what seemed to be a few months. (Courtesy of the West Virginia Parkways Authority.)

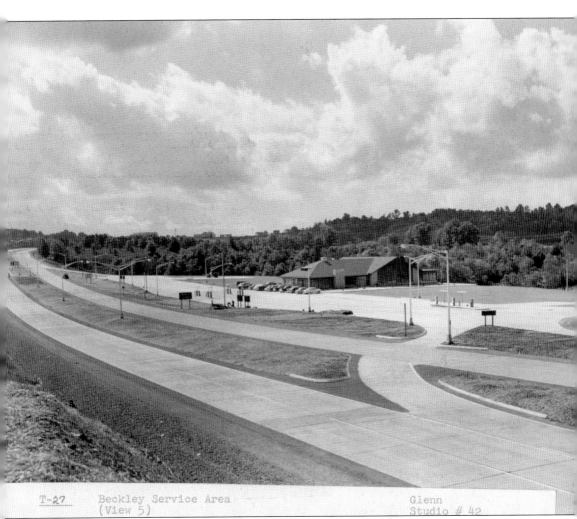

T-27 Beckley Service Area Glenn
 (View 5) Studio # 42

One of the challenging aspects of superhighways is to safely allow cross traffic to enter alternating lanes safely. In the 1950s, with most speed limits in the 55-mile-per-hour range, the challenge was not as difficult as it would eventually become. The configuration of the traffic pattern at the original Beckley Glass House might have looked good on paper but could not pass muster on a high-speed modern highway. Of course, the science of transportation had to change quickly, and soon, the crossing system, shown here, was abandoned, and motorists traveling north would have to travel about three miles to exit 48, exit the turnpike, and double back southbound to the glass house. Southbound motorists were fine unless they wanted to go north. In that case, they would have to drive to Exit 44 and circle back to the northbound turnpike. (Courtesy of the West Virginia Parkways Authority.)

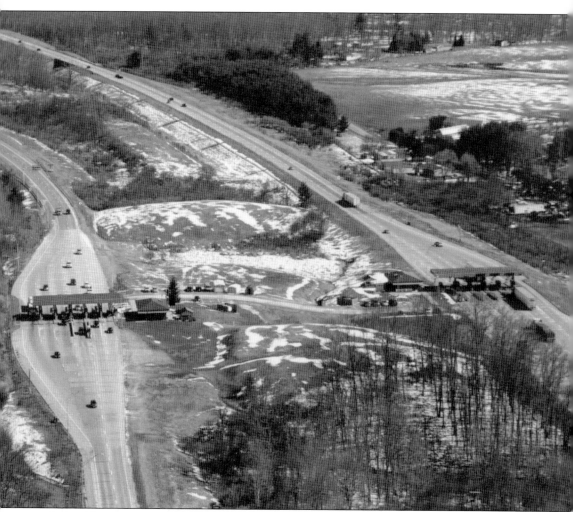

It should come as no surprise that from late fall to early spring, the mountains of south-central West Virginia receive snow. Sometimes the mountains receive a light dusting, as seen in the photograph above, but more often than not, there are bound to be a few major snowstorms every season. Sometimes the snow is light and fluffy, but at other times, the snow is wet and deep. Either way, the West Virginia Parkways snow-removal crews stationed in Charleston, Beckley, and Ghent are out plowing and treating the roads. Snowstorms in recent years have been as challenging as recorded snowstorms from 100 years ago or more. One of the most challenging recent storms was a 33-inch dry snow that fell on March 13, 1993. The fact that the snow was combined with subzero temperatures that remained below freezing for several days compounded the treacherous conditions. (Courtesy of the West Virginia Parkways Authority.)

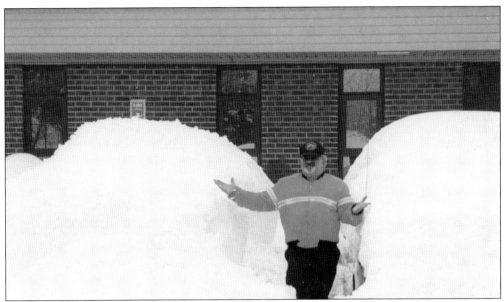

West Virginia Turnpike snow-removal crews often have to dig their way out of a surprise snow in order to get to their trucks. Another heavy wet snow that slowed traffic in the mountains occurred in late January 2006. Although the storm only brought 26 inches of snow, the snow's water content presented a challenge on two levels. First, the heavy snowfall caused extensive trees to fall and damage communications lines. Satellite communications were spotty at best as accumulations in rooftop discs prohibited signals from getting out. (Courtesy of the West Virginia Parkways Authority.)

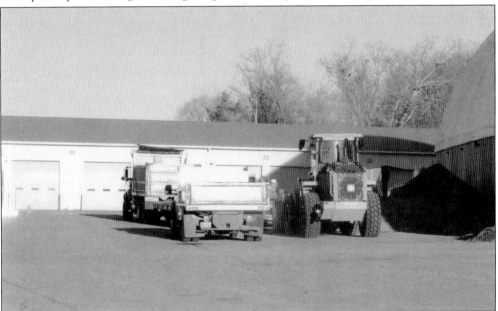

Highway maintenance and snow-removal equipment are prepared for any situation Mother Nature might throw at West Virginia. While contract specialists traditionally tackle larger tasks like highway resurfacing or bridge-deck replacement projects, the parkways authority highway crew personnel are equal to the day-to-day tasks that keep the turnpike safe for motorists to travel. (Courtesy of the West Virginia Parkways Authority.)

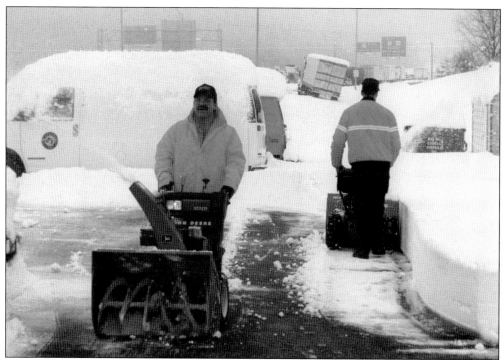

Deep snows can cause nightmares for commercial tractor trailer operators as well as parkways authority snow-removal crews, but the secret to winter driving in the mountains is to be prepared for whatever happens. Snow-removal crews with snowfalls of more that a foot or two know that a slow and steady approach is always the best. While winter conditions can be frustrating to travelers—whether commercial, work travel, or vacation—patience is a virtue when operating a vehicle in any adverse weather conditions. (Courtesy of the West Virginia Parkways Authority.)

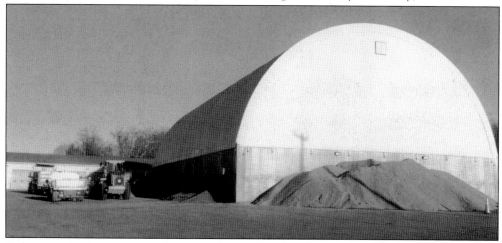

Parkways authority snow-removal personnel stockpile salt in the Quonset-style building shown here at the southernmost maintenance site on the turnpike. The fine stone material behind the Quonset hut can be used to provide more traction on ice-covered roadways. While there are many potential approaches to addressing a variety of highway conditions in the winter, experience, equipment, skill, and patience all play an important role in maintaining safe surfaces for automobile travel. (Courtesy of the West Virginia Parkways Authority.)

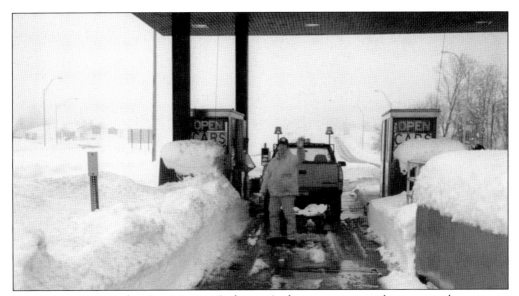

When snow says no, the West Virginia Parkways Authority winter weather crews at locations in Charleston, Beckley, and Ghent spring into action. With many combined years of experience as well as modern, well-maintained equipment, the crews are focused on ensuring the safety of motorists caught in adverse weather conditions while still out on the highway as well as clearing the highway and its interchanges as quickly as possible. A snow-removal crew member is shown here motioning for traffic to halt as crew members clear snow at a toll booth. (Courtesy of the West Virginia Parkways Authority.)

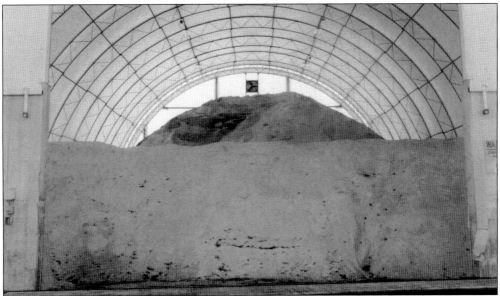

This massive dome contains enough salt to treat the southern section of the turnpike for at least the start of the snow-removal season. Winter in the Appalachian Mountains differs from year to year, but with all the technology that modern meteorologists have at their fingertips, long-range weather forecasts are still an inexact science in terms of long-range predictions. However, short-term forecasting can provide turnpike snow-removal crews information in order to prepare for significant snow events. (Photograph by the author.)

The West Virginia Parkways Authority's maintenance station at the Ghent exit (above, right) maintains equipment that can address challenges presented by most extreme weather conditions. While parkways authority employees have specific responsibilities, on all manner of challenges, they work closely with snow-removal and maintenance crews with the West Virginia Division of Motor Vehicles. There is a mutual level of esprit de corps among the folks who work to keep all highways safe for travelers. (Courtesy of the West Virginia Parkways Authority.)

Snow-removal crews work around the clock to clear the turnpike and treat the road surface with salt to remove ice from the road. Crews traditionally exchange information during shift changes to alert oncoming crew members of anything that may or may not need an increase of attention. While grades on the turnpike are uniformly gradual, the many bridges and curves frequently require special treatment. Shift-change communications help provide a continuity to inclement weather responses. (Courtesy of the West Virginia Parkways Authority.)

When West Virginia governor Gaston Caperton took office in 1989, he took special interest in the development of the West Virginia Turnpike. While the turnpike is not without its critics, it is a symbol of pride for most West Virginians. One of Caperton's first tasks in office was to eliminate the side tolls, but he also visited the site of the West Virginia Welcome Center in Princeton. Gov. John D. "Jay" Rockefeller had announced the site location before leaving office in 1988, but Caperton wanted to see it for himself. (Courtesy of the West Virginia Parkways Authority.)

The level, grass-covered site of the future structure was strewn with several pallets of stone that would one day cover the walls of the unique structure. There was some concern locally because the site would be located at Exit 9, rather than Exit 1, the first exit in West Virginia after exiting the H. Edward Steele Memorial Tunnel, located in both Virginia and West Virginia. But with limited available space at Exit 1, and good ground at Exit 9, engineers settled on the Princeton site. Passersby soon enjoyed watching the construction of the facility with glass roofs that resemble pyramids and exterior walls of stone. As time passed, the active members of Chapter No. 628, Vietnam Veterans of America, worked to raise funds for a monument that would honor soldiers who were killed in action while serving in the war. The memorial honors soldiers killed in action from Mercer, McDowell, and Monroe Counties in West Virginia as well as those killed in action from Bland and Tazewell Counties in Virginia. (Photograph by Melvin Grubb.)

Five

TAMARACK

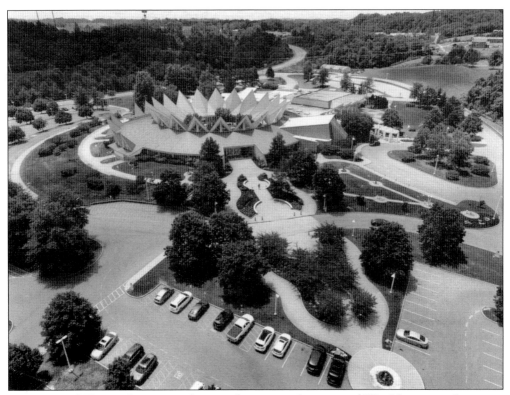

West Virginia's Tamarack is a center for art, reflection, conferences, and West Virginia art. In nature, a Tamarack (*Larix laricina*) is a deciduous conifer whose green needles turn yellow in fall before shedding. First Nations Abenaki Northeastern Woodland people called the tree Hackmatack, an Abenaki word meaning "the wood is good for making snowshoes, toboggans, and canoe parts." Tamarack, at Exit 45, can be many things to many people, just as the tree from which its name derives. (Courtesy of Randall Hash.)

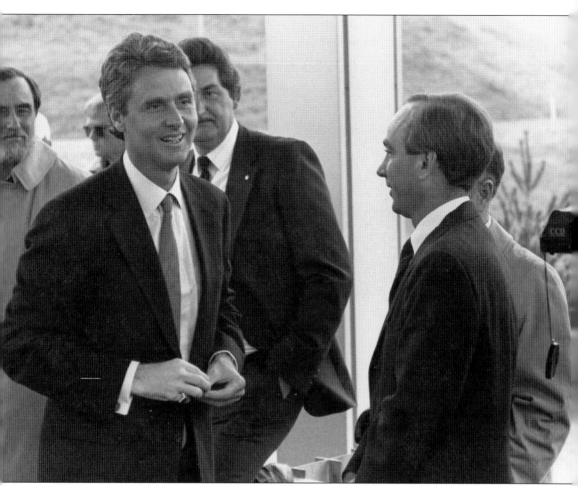

West Virginia governor Gaston Caperton (left) had a lot to smile about when Tamarack officially opened in May 1996. Governor Caperton and David Dickirson, a former member of the West Virginia Parkways Authority, dreamed of erecting a statewide marketplace for the work of artisans and artists of West Virginia. For years, expert woodcarvers, quilt makers, musical instrument makers, and craftswomen and men had sold their wares at wide spots, intersections of secondary roads, and flea markets, but Caperton and Dickirson thought a centrally located spot on the turnpike would provide juried artisans, artists, and crafters a marketplace for their creations. Dickirson said that during the grand opening of the West Virginia Welcome Center on October 28, 1992, which included good food, music, and crafts, that the idea for Tamarack was born. (Courtesy of the West Virginia Parkways Authority.)

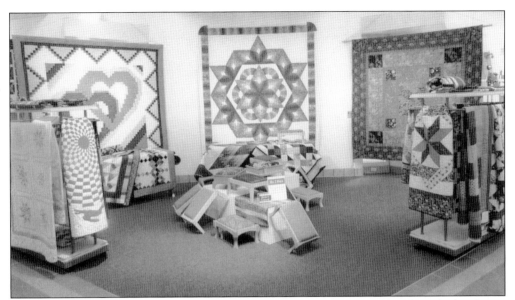

Quilting has been a longtime passion of West Virginia seamstresses, and hand-stitched and even some machine-stitched quilts with roots in West Virginia command good prices at local or regional craft shows or public auctions. Several quilting guilds in the Mountain State provide an opportunity for artists of cloth and thread to learn, socialize, and make friends. Quilts on display at Tamarack are juried and are made available to guests at the showplace. In the matter of quilting, Tamarack provides a spotlight for this exceptional craft. (Photograph by the author.)

West Virginians are passionate about flowers but know that wild and domesticated flowers have limits in nature. However, a bright, decorated open space around any home can be enhanced with colorful crafted flowers along with welcoming signs. Of course, nothing can compare to the incredible beauty of West Virginia wildflowers, but fanciful creations can get any horticulture purest through the dark winter season in the mountains. (Photograph by the author.)

Fiesta dinnerware, introduced by the Homer Laughlin China Company in 1936, has a nationwide and global reputation for simplistic beauty and durability. Homer Laughlin, founder of the company, was born in eastern Ohio. After service in the 115th Ohio Volunteer Infantry Regiment during the American Civil War, Laughlin imported English earthenware for sale. In 1873, Laughlin and his brother Shakespeare built a pottery in East Liverpool, Ohio. In 1896, Laughlin opened the Homer Laughlin China Company in Newell where it remains today. (Photograph by the author.)

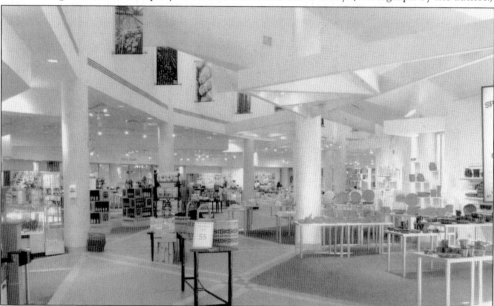

Tamarack's incredible open space provides visitors with an opportunity to examine an array of West Virginia artistry. After Caperton's epiphany on creating a marketplace that catered to all West Virginian artists, the task of making that vessel was placed in the capable hands of Cela Burge, then West Virginia's director of economic development and tourism. Burge met with crafters statewide who helped her strategize an approach to establish a vehicle to serve artists. Dickirson stated in a *MetroNews* article that Caperton's staff visited other states to learn their approaches. (Photograph by the author.)

For Caperton's vision of creating a first-class marketplace for talented artists, artisans, and craftswomen and men, the West Virginia Parkways Authority expressed its appreciation with bronze and stone. The monument dedicated to Caperton stands near the main entrance to Tamarack. The authority awarded the design of the project to Doug Bastian and John Harris in May 1993—just eight months after the project's conception. A Beckley firm, Radford & Radford, was awarded the construction project. (Photograph by the author.)

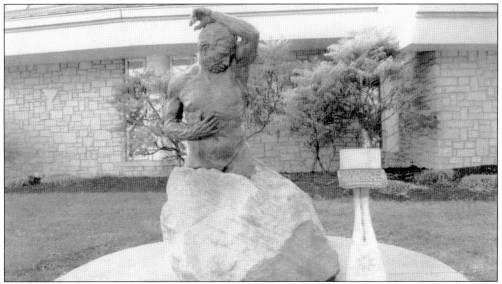

West Virginia sculptor Bill Hopen created this work, *Mortality*, for the untold number of workers who died from tunneling through silica during the construction of the Hawk's Nest Tunnel, located about 30 miles from Tamarack. The tunnel was designed to divert water from the New River to a private power plant at Gauley Junction. The tunnel project started in 1930 and was completed in 1935. Perhaps as many as 1,000 workers died in the construction and were buried in unmarked graves near the tunnel site. (Photograph by the author.)

This bronze sculpture, titled *The Best of West Virginia*, represents the many hands that worked diligently to make this incredible marketplace for artists and is located near the main entrance to Tamarack. While Tamarack continues to celebrate the arts, the restaurant provides standard fare with a decidedly southern West Virginia slant. Newcomers to Tamarack are usually awed by the beauty of the structure and grounds, but the artistry within helps artists, artisans, and crafters find new homes for their lovingly prepared works of art. (Photograph by the author.)

Tamarack's well-kept exterior grounds provide an attractive welcome to visitors. Some works of art have been on display for several months, and others are relatively new. From a thematical approach, the grounds surrounding Tamarack are like the conifer (also known as an eastern or American larch) that the structure is named for. The needles are green like most conifers but turn a yellowish gold tint in the fall. The concept benefits West Virginians and visitors as well. (Photograph by the author.)

Nik Botkin created this sculpture by welding an armature of steel pipe together in the form of a branching tree. Then he cut small pieces of 16-gauge mild steel sheet and welded them in place in a manner that resembles bark. Far away or from very close, the sculpture appears to be a barren tree. The artistry involved is incredible, but the instruments employed by the artist are simplistic. Not all welders in West Virginia become artists, but all are skilled crafters in their own right. (Photograph by the author.)

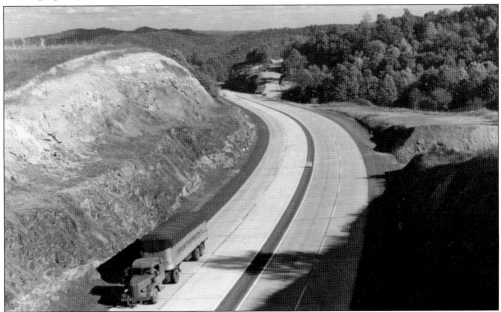

Trees are a prevalent feature of every mile along the West Virginia Turnpike. The scenery changes with each season, making the views spectacular. The progressive individuals who envisioned the highway were aware of the beauty because many had traveled the winding south-central mountain road. A modern four-lane highway with a uniform 600-foot line of sight made the experience enjoyable. (Courtesy of the West Virginia Parkways Authority.)

A bronze plaque near the front entrance dated June 19, 1996, proudly states the following: "Tamarack . . . The Best of West Virginia. This one-of-a-kind facility, conceived and built during the term of Governor Gaston Caperton, is dedicated to his vision, wisdom and love for West Virginia and its people." Indeed, West Virginians have an incredible strength forged by challenges, loss, and heartbreak but tempered by love of nature and love of mankind. As the only state in the union that gained statehood during the height of the American Civil War on June 20, 1863, West Virginians are proud of where they come from and proud of who they are. The artistic blown-glass pieces shown above may be the product of rough hands that toil in the state's glass plants, but the delicate work those hands create are nothing short of excellent. (Courtesy of Tamarack.)

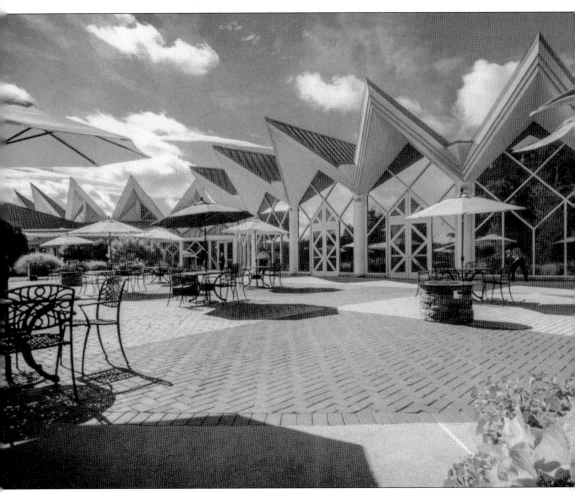

Whether dining alfresco or just sitting a spell to reflect on all manners of things, a few moments near the veranda outside Tamarack's conference center can restore positive thoughts and refresh the soul. During daylight hours, peaceful tableaus of natural beauty float past the pointed gables of the roof, and at night, lights in the foyer within illuminate the flow of patrons entering the spacious yet intimate conference center. With such a humble origin, Tamarack has an aesthetic appeal that captivates the imagination of first-time and frequent visitors as well. The restaurant at Tamarack offers a wide variety of delicacies, but anglers in one's group might like a bite of the rainbow trout. However, most visitors enjoy the genuine West Virginia hospitality that beams from the Tamarack staff. That genuine uncompromising West Virginian hospitality has been Tamarack's trademark since opening in 1996. (Courtesy of Tamarack.)

The exterior windows of the foyer in Tamarack's conference center are a study in triangles and squares. Every element in the structure enhances the timeless appeal of the building. In May 1993, Clint Bryan and his associates Doug Bastain and John Harris proposed a design that would draw visitors in to appreciate every aspect of the structure while being true to an artistic yet utilitarian purpose. A Beckley, West Virginia, firm, Radford & Radford won the construction project. (Courtesy of Tamarack.)

West Virginia governor Gaston Caperton, pictured at right, was interested in both the overall esthetic appeal of Tamarack as well as recruiting the Mountain State's most creative artists and artisans to showcase their work both inside and on the grounds of the facility. Tamarack's staff, along with well-established art jurors, carefully judge and select works to be displayed. In June 1996, Tamarack had placed orders for works of art from 900 state artists and artisans. From Tamarack's opening in 1996 to the close of the first year five months later, more than 450,000 people had visited the center, and sales topped $3.3 million. (Courtesy of the West Virginia Parkways Authority.)

By the end of its first half-year of operations on December 31, 1996, Tamarack's one-millionth visitor had entered the facility. While many travelers visit Tamarack as a break during their travels, travelers from throughout West Virginia are also frequent visitors. Since the internal displays are a work of art in their own right, there are always many things to see. For more than 50 years, West Virginia has lost population, but while they may be living in other states or nations, many include visits to Tamarack when seeing family or just passing through. (Courtesy of Tamarack.)

Metal sculptor Mark Schwenk titled this work on display in Tamarack's front courtyard *Cooperation*. As in many works of art, seemingly divergent components can be joined together to form something totally unique, while, at times, perplexing and engaging. Artists who use metal as their medium often allow the art to emerge during the process of creating. Visitors can be captured by the essence of a work without understanding the concept behind its creation. (Photograph by the author.)

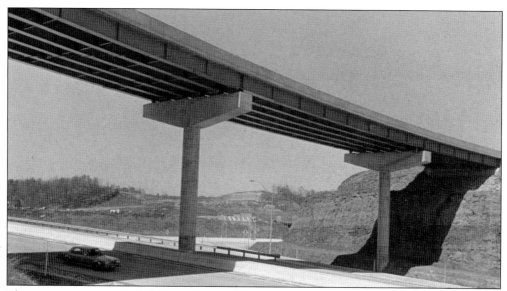

There is a certain artistry in the creation of the West Virginia Turnpike. While the work of highway architects is primarily focused on building structures that will support the weight of traffic and survive weather extremes, there remains a salient beauty in the structures themselves. While art is in the eye of the beholder, travelers can also enjoy the art created during various stages of highway construction. (Courtesy of the West Virginia Parkways Authority.)

The fanciful sculpture here in Tamarack's front courtyard is titled *Fiddle-headed Ferns* by Michael Sizemore of Mountain Works. The colorful swirls in this work are attractive, but the highly skilled metalwork makes this sculpture an eye-catching piece. Tamarack visitors can enjoy beauty both in the center and outside of it. (Photograph by the author.)

At first glance, this otherworldly sculpture is hard to explain, but in a moment, the viewer can see that it is a stylized bovine . . . a pig, or two. Artists often capture the essence of animals they see. Many farm folks grew up slopping the family's hogs. There is nothing romantic about that chore, but to an artist, the lines and essence of an animal are beautiful. However, the sculpture here may not be an animal at all. It is what is in the eye of the beholder. (Photograph by the author.)

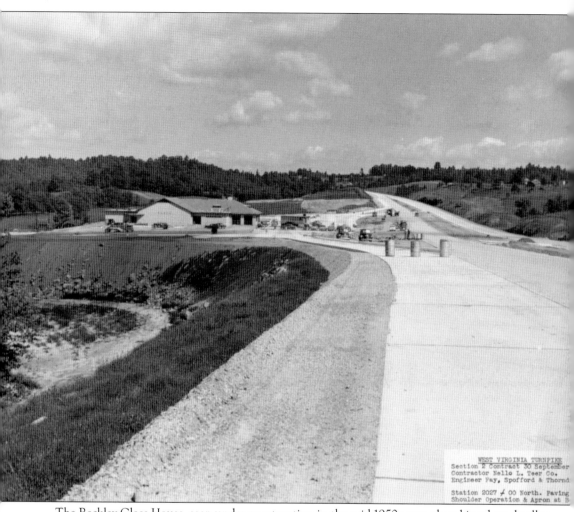

The Beckley Glass House, seen under construction in the mid-1950s, was placed in a broad valley of farmland near the city of Beckley. Interstate highways of the time had yet to adopt the sweeping curves for exit and entrance ramps. Crossing a southbound two-lane highway to enter a northbound two-lane highway would have been risky at 55 miles per hour, but at 65 or 70 miles an hour, only race cars could perform the task safely. (Courtesy of the West Virginia Parkways Authority.)

From the start of construction to present day, events associated with the West Virginia Turnpike have drawn media attention. In 1955, Jack Thiessen of *BIG* magazine, characterized the turnpike as follows: "Eighty-eight miles of miracle." The May 8, 1954, edition of *Business Week* called the turnpike "a trucker's dream." Through the years, the dream has evolved due to the steadfast and innovative leadership, the workforce's commitment to excellence in all projects, and the pride West Virginians have in their state. When events occur on the turnpike, those events are usually covered by statewide television, radio, and print media. The rugged mountain setting, a modern thoroughfare that provides access to the heart of south-central West Virginia, and the powerful beauty in all seasons combine to make each journey newsworthy. (Courtesy of the West Virginia Parkways Authority.)

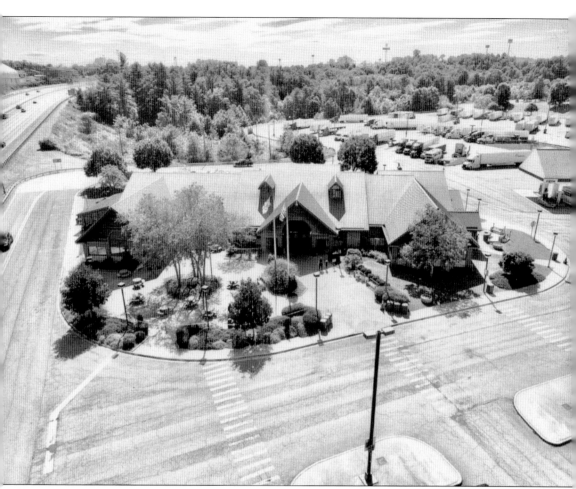

The former Beckley Glass House at Exit 45 is on the slate for a major overhaul in 2023. The renovation of both the Beckley and Bluestone travel plazas will start with demolition on both sites. Erection of the two new sites is expected to be complete in late 2024. In May 2022, the West Virginia Parkways Authority approved a $152 million bond, spread out over three years, to undertake the dramatic overhaul of the two travel plazas. While the service plazas will be closed during the process, existing tractor trailer parking, refueling areas, and comfort (restroom) facilities will still be available. Also in 2022, the West Virginia Parkways Authority completed a project that involved adding a third lane for traveling on the oft-congested area between Exits 40 and 48, which can be seen in the photograph above. (Courtesy of Randall Hash.)

West Virginia governor Jim Justice (left) and West Virginia Parkways Authority executive director Jeffrey A. Miller (right) are shown here at a press conference at Tamarack on October 6, 2022, to announce the designs for the upgrade to the travel plazas in Beckley and Bluestone. During the press conference, Governor Justice stated, "Each year, 3.3 million people travel the West Virginia Turnpike." He added that the new facilities will showcase everything the state has to offer. The West Virginia Parkways Authority conducted a survey distributed to travelers at the plazas. More than 3,400 travelers responded to the survey, which guided plaza designers. Miller was hired as the authority's second executive director. The turnpike's first executive director was Ray Cavendish, who served from 1949 to 1956. Then the following served as general managers for the West Virginia Parkways Authority: Okey L. Paterson, (1954–1956), W. Earnest Stahl (1956–1971), George A. McIntyre (1971–1991), William H. Gavan (1992–1999), Lawrence F. Cousins (1999–2002), and Gregory C. Barr (2002 to 2020). Miller began his service on August 1, 2020. (Courtesy of C.J. Harvey, press secretary to Gov. Jim Justice.)

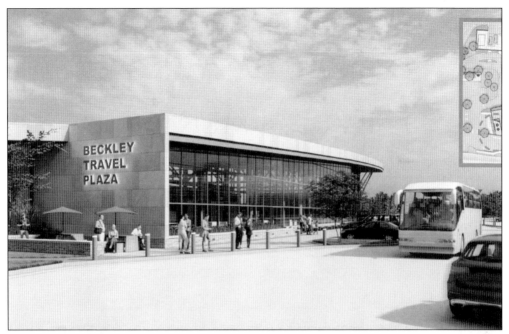

An artist's rendering of the proposed design of the Beckley Travel Plaza's bus plaza features sleek new lines as well as facilities to serve tour groups and others traveling by bus. This and other images were available for public viewing during Gov. Jim Justice's November 18, 2022, press conference announcing the project. (Courtesy of C.J. Harvey, press secretary to Gov. Jim Justice.)

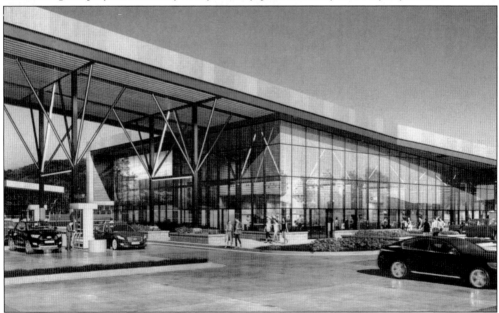

Drawings for the proposed Bluestone Travel Plaza were also distributed during the press conference at Tamarack. Like their predecessor plazas since 1955, the travel plaza features large glass windows so visitors can observe the incredible natural setting that not only surrounds the plaza, but also surrounds every inch of the 88-mile West Virginia Turnpike experience. (Courtesy of C.J. Harvey, press secretary to Gov. Jim Justice.)

Six

DEVELOPMENT OF SOUTHERN WEST VIRGINIA

The West Virginia Parkways Authority guides and directs the turnpike and its roughly 350 employees. Gov. Jim Justice is the formal chairman of the board. Byrd E. White III is presently serving as the governor's chairman designee. Other board members include Jimmy D. Wriston, cabinet secretary, West Virginia Department of Transportation; Tom Mainella, board secretary; Thomas T. Joyce, member; Alisha Maddox, member; Douglas M. Epling, member; and J. Victor Flanagan, member. The board is shown here at a meeting in the summer of 2022. Executive director Jeffrey A. Miller is also pictured here. (Courtesy of the West Virginia Parkways Authority.)

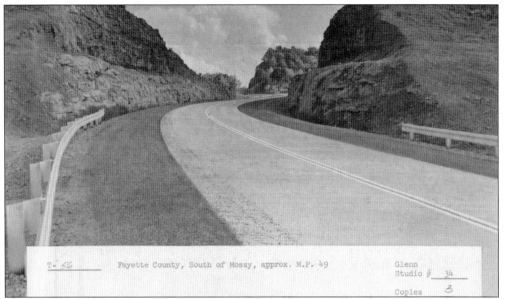

From its opening in 1954 to the present, motorists can observe the incredible exposed stone that display thousands of years of mountain-building process during the Paleozoic Era. To the east, the Acodian Trough forms a portion of the so-called "Valley of the Virginias." The western region on display above shows portions of the Cordilleran Geosyncline. The Appalachian Mountains formed some 500 to 300 million years ago and are among the oldest mountain ranges on Earth. (Courtesy of the West Virginia Parkways Authority.)

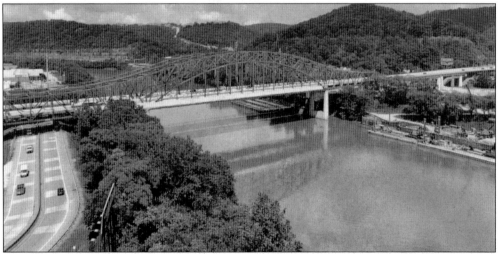

The beautiful Yeager Bridges across the Kanawha River are among the most beautiful structures on the turnpike. Each bridge is 70 feet above the Kanawha River, and combined, they are 2,166 feet long. There are two more named bridges on the turnpike, including the Miller and Brogan Memorial Bridge, which honors Bobby Lee Miller and Homer Ray Brogan, members of a turnpike crew who were repairing a bridge at mile marker 74.3 and perished, and a bridge at mile marker 14 honoring Constable Joseph Davidson, who was murdered in the line of duty in 1934—the only constable line of duty death in state history. A bridge on US Route 19 crossing the turnpike at mile marker 24 honors Nathan Thompson and Richard Lambert, who were killed while directing traffic in August 2018. (Courtesy of Randall Hash.)

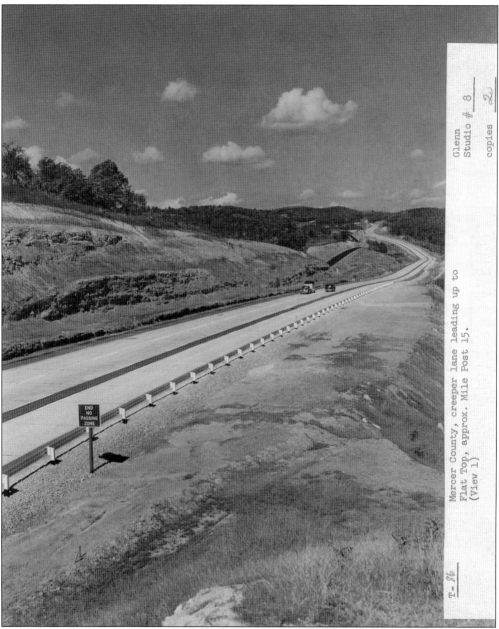

Nine construction workers died on the job during the initial construction phase of the West Virginia Turnpike project. The workers were honored in a "Memoriam" on the final page of the November 8, 1954, dedication program. The following is a list of those workers who died on the job: James W. Anderson of Crown Hill, West Virginia; Robert Wilson of Spencer, West Virginia; Rodney Davis of Spencer, West Virginia; Kevin Brooms of Robinsville, North Carolina; Tommy Branch of MacArthur, West Virginia; Mason Perry, of Athens, West Virginia; Orvan H. Long of Ballard, West Virginia; John Lester Miller of Lenoir, North Carolina; and John Howard Camden of Oakvale, West Virginia. Their deaths occurred at various locations along the turnpike, spanning six months starting on October 17, 1953 and ending on April 7, 1954. (Courtesy of the West Virginia Parkways Authority.)

The parkways authority commuters' E-ZPass program, an electronic toll collection system, uses transponder-based technology to electronically record toll usage in the turnpike. In addition to reducing time while traveling on the West Virginia Turnpike, the transponder, which is mounted on the windshield of a passenger vehicle or on the roof or license plate of a commercial vehicle, can be used on all existing or future toll roads, bridges, or tunnels in the northeastern United States. (Courtesy West Virginia Parkways Authority.)

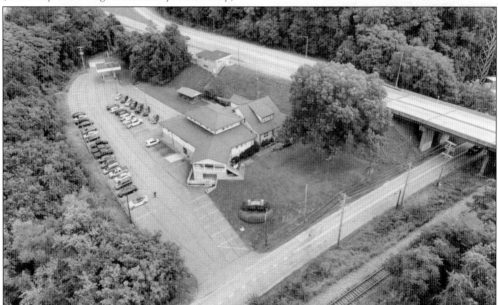

The West Virginia Parkways Authority headquarters is located at 3310 Piedmont Road, Charleston, West Virginia. In addition to a spacious boardroom, the facility has a few offices and a large reception area. There are a total of 350 full-time parkways authority employees who serve the authority; three maintenance sections; four toll plazas; toll equipment maintenance; a dispatch center; two customer service locations; as tourist information personnel at West Virginia Welcome Centers at the Princeton, Bluestone, Beckley, and Morton Travel Plazas; courtesy patrol; information technology; purchasing and procurement; human resources; and operations and training. (Courtesy of Randall Hash.)

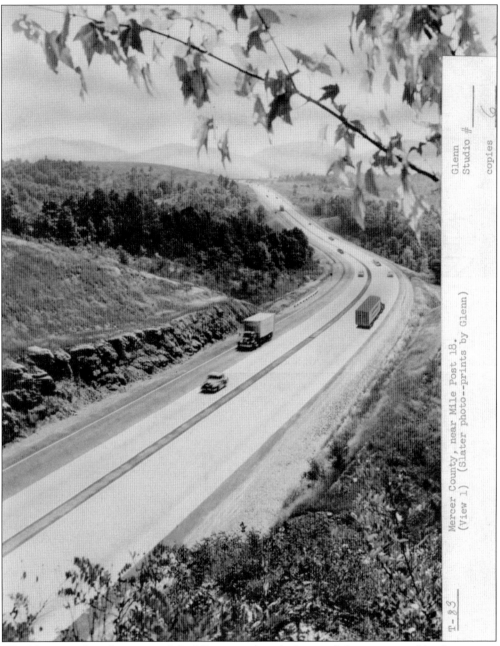

West Virginians have long enjoyed the fall season when the leaves of a large variety of deciduous trees in the mountains change. For the past several years, the West Virginia Department of Tourism has been promoting to the Mountain State for fall foliage tours. Various convention and visitors bureaus work to schedule events to coincide with peak foliage periods, and the state tourism department posts regional alerts to prospective visitors who love to see the natural kaleidoscope of colors courtesy of West Virginia's diverse hardwood forests. A few state travel councils started promoting fall foliage tours in the mid-1980s, and that promotion has grown and is on the verge of enjoying a 40th annual celebration. The trees shown here in Mercer County at mile marker 18 are among the most beautiful trees on display in the fall. (Courtesy of the West Virginia Parkways Authority.)

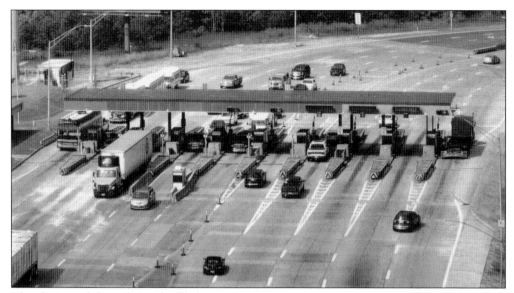

The photograph here shows the Chelyan tollbooth on a slow day. The site is a few miles south of the community of Chelyan, located on the southern shore of the Kanawha River. It is the first toll plaza for southbound vehicles and last for northbound traffic. While the E-ZPass has eased some of the holiday congestion at Chelyan, during the summer holiday travel period as well as on most holiday weekends, traffic can back up at the gates. However, personnel appear to handle the heavy traffic flows with grace and professionalism. To the West Virginia Parkways Authority, they are on the front lines of West Virginia hospitality. (Courtesy of Randall Hash.)

Red means stop and green means go at the Chelyan tollbooth. The photograph here shows the transponder units in the three westernmost southbound lanes with non-transponder reading devices to the east. With increased technology, all lanes are now capable of reading transponders. In 2016, West Virginia residents were given the opportunity to sample a three-year E-ZPass transponder for a nominal fee. In 2021, the program changed to an annual renewal fee, but it remains a popular program among West Virginians. (Courtesy of the West Virginia Parkways Authority.)

The modern Morton Travel Plaza is not scheduled for remodeling in 2023–2024, so travelers will still be able to enjoy the amenities that exist at this site during the upgrades at Beckley and Bluestone. Nestled on the banks of Paint Creek in Kanawha County, the Morton site has long been a meeting place for travelers on their way to Charleston. While Morton's footprint is not as large as its sister travel plazas, staff are traditionally helpful and friendly to visitors. (Courtesy of Randall Hash.)

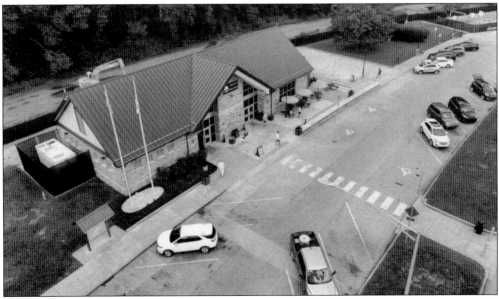

Paint Creek Rest Area 69 was, for years, a little more than a wide spot on the southbound side of the turnpike. As the small pull off grew in popularity, the parkways authority started the work of bringing to the site public water and a wastewater treatment facility, located in the upper right corner of the photograph. Without much fanfare, a structure was erected to house snack and soda machines and restroom facilities. The site has become a popular stop for southbound truckers and motorists. (Courtesy of Randall Hash.)

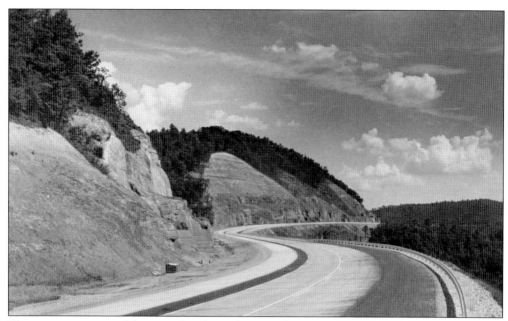

The sweeping curves of the turnpike, shown here on Flat Top Mountain during the first phase of construction, provided roadside room for motorists to pause and enjoy the scenery. Spectacular sunrises over fog-laden valleys are especially nice, but the mountaintop site is exciting in all seasons. Flat Top Mountain begins in Monroe County and extends westward through Summers, Mercer, Raleigh, McDowell, and Wyoming Counties. (Courtesy of the West Virginia Parkways Authority.)

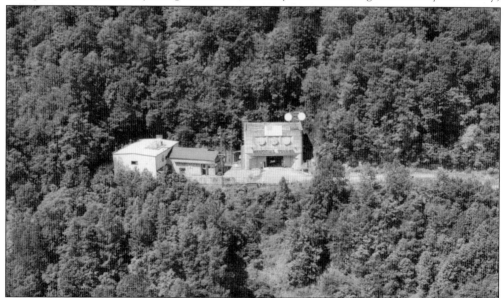

While the first Stanley Bender Bridge is gone, the Memorial Tunnel continues to serve a non-motorist function. In 1991, the Massachusetts Department of Transportation (Mass DOT) leased the tunnel. Throughout the last decade of the 20th century, Mass DOT conducted fire ventilation tests to see how much heat the tunnel could withstand. Those studies were used in Boston's "Big Dig" subterranean highway. The studies also provided useful information for the construction of the English Channel Chunnel project between England and France. (Courtesy of Randall Hash.)

The Ghent tollbooth is the first northbound booth on the turnpike, which begins at Exit 9 in Princeton, West Virginia. The lay of the land on Flat Top Mountain dictated a separation of more than 200 yards between the tollbooths. The Ghent booth is located at mile marker 22. As a result, motorists travel the first 13 miles of the turnpike before encountering the first tollbooth. Ghent is an unincorporated community in Raleigh County and serves as headquarters for the southernmost maintenance section. (Courtesy of the West Virginia Parkways Authority.)

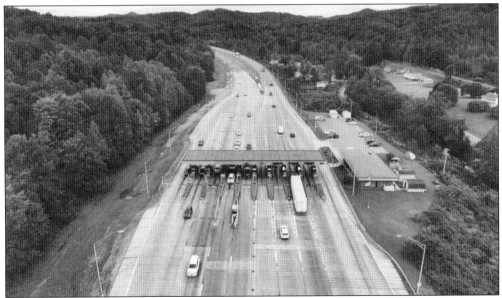

Unlike its partner in Raleigh County, the Pax tollbooth serves both north and southbound traffic. While the Chelyan and Ghent tollbooths tend to experience backups during peak travel periods, the Pax toll area seems to maintain a modest constant flow. With a total of 10 lanes—five northbound and five southbound—and an extended level approach from both directions, travelers through Pax face routinely only moderate delays even during peak holiday periods. Chelyan and Ghent have steep mountain climbs in both directions. (Courtesy of Randall Hash.)

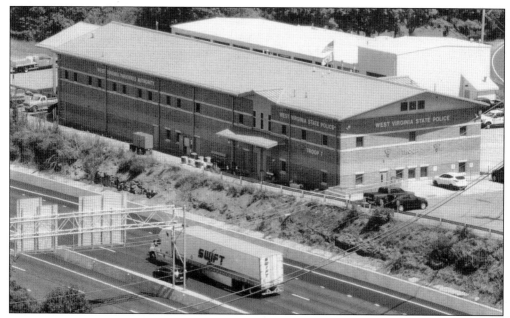

The West Virginia State Police Troop No. 7 is based in this building on the eastern side of the turnpike at Exit 44. In addition to the headquarters, Troop No. 7 maintains detachments in Princeton and Charleston. The parkways authority has roster positions for 31 troopers, but at this writing, there are 26 on active duty with 2 on active deployment. According to the parkways executive director Jeffrey A. Miller, the number of troopers on active duty at any given time is 28. (Courtesy of Randall Hash.)

The scenery has changed over time, but most Mercer County folks will recognize the community in the curve, shown in this photograph, to be Melrose. While southbound traffic was expanded to two lanes, the northbound lanes increased to three with the creeper lane, as it was called in the 1950s. After decades of operating motor vehicles on the narrow, winding county—and later state—roads, driving on the turnpike must have been a unique experience. (Courtesy of the West Virginia Parkways Authority.)

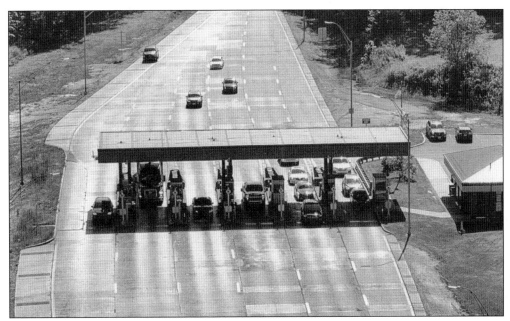

The southbound tollbooth at Ghent is the final booth on the West Virginia Turnpike. During the winter months, Flat Top Mountain traditionally receives more snow than the surrounding areas. While snow may cause problems for travelers, the sight is music to the ears of avid snow skiers. The first ski slope on Bald Knop at Flat Top Mountain launched in 1958—just four years after the turnpike opened. (Courtesy of Randall Hash.)

The 350-strong West Virginia Parkways Authority staff takes pride in their work and seems to always give a welcoming smile to travelers. During peak travel periods, tempers can flare, but a smile can be a mighty tool for disarming even the most stressful situation. (Courtesy of the West Virginia Parkways Authority.)

In recent years, the curve at the foot of Flat Top Mountain at mile marker 22 has become the site of several fatal accidents primarily caused by excessive speeds, faulty equipment, or driver error. The West Virginia Division of Motor Vehicles has increased commercial vehicle inspections in the area. Troop No. 7 of the West Virginia State Police has increased its presence in the area, and the West Virginia Parkways Authority placed cautionary flashing signage in both north and southbound lanes, which has had a positive effect on reducing accidents in that curve. (Photograph by the author.)

The Bluestone Travel Plaza, shown here in 2022, is scheduled to undergo a dramatic remodeling program in the near future. The West Virginia Parkways Authority sought and received comments from some 3,000 respondents to a questionnaire seeking suggestions as to how the existing plazas could better serve the traveling public. In response, the authority developed an architectural structure that will better serve the traveling public. (Courtesy of Randall Hash.)

Seven

FACE-LIFT OF THE FUTURE

Trooper Paul Powell of Troop No. 7, West Virginia State Police, served over 35 years as the "toll messenger." His duty was to start every morning at 3:00 a.m. and drive from Princeton to Charleston, picking up the tolls collected during the previous day. Trooper Powell also distributed mail and supplies to the tollbooths on his journey, which culminated at 9:00 a.m. each morning at the Charleston headquarters when the banks opened and staff could prepare the receipts for deposit. Trooper Powell drove about two million miles serving as the toll messenger. (Courtesy of the West Virginia Parkways Authority.)

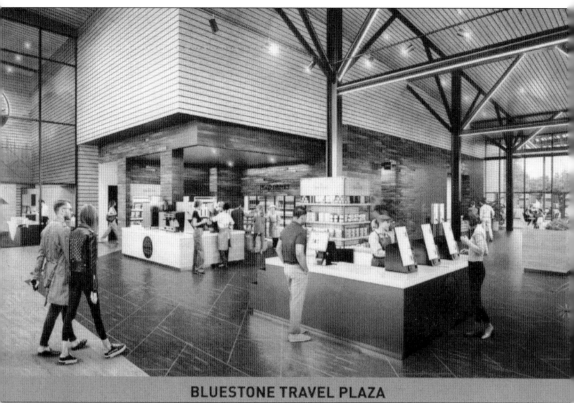

BLUESTONE TRAVEL PLAZA

The artist drawing of the travel plaza upgrade project for Bluestone is shown here. The Bluestone Gorge is one of West Virginia's most beautiful chasms, but because of its remote location, it remains undeveloped. To those in the conservation community, that is a good thing. The West Virginia Nature Conservancy, the Mercer County Commission, and local hiking enthusiasts hope to open the unspoiled region to a nonmotorized tourism experience by improving pedestrian trails in areas where endangered plant species exist, or to bicycle use in non-endangered areas. As the trail system grows, trail organizers hope to expand on the existing equestrian trail system at Camp Creek State Park at West Virginia Turnpike Exit 20. (Courtesy of the West Virginia Parkways Authority.)

This line from one of West Virginia State's many songs, "Oh the West Virginia hills, so majestic and so grand; With their summits bathed in glory, like our Prince Immanuel's Land," perfectly describes the 88-mile experience that is the West Virginia Turnpike. "The West Virginia Hills" was the state's first official state song. The lyrics were first published on September 25, 1885, in the *Glenville Crescent* newspaper and attributed to Ellen (Ruddell) King. In the years that followed, some questioned King's authorship of the poem and suggested that her husband, Rev. David H. King, actually wrote it because of its religious overtones. H.E. Engle provided the musical score to the song. It was accepted as the state song early but was reaccepted by the legislature on February 3, 1961. The legislature has selected other state songs, including, most recently, "Take Me Home, County Roads" by Bill Danoff, Taffy Nivert, and John Denver, thanks to Dreama Denver in March 2014. (Courtesy of the West Virginia Parkways Authority.)

West Virginia governor Jim Justice is shown here discussing new West Virginia Turnpike developments with his beloved Baby Dog at his side. During the dark days of the coronavirus pandemic in 2020 and 2021, the governor and Baby Dog made regular appearances to promote cautionary protective measures as well as to promote vaccines. Baby Dog became a canine celebrity during the height of the pandemic and, for West Virginians, a welcome relief from the uncertainty of the global health emergency. (Courtesy of C.J. Harvey, press secretary to Gov. Jim Justice.)

In 1955, Princeton businessmen Dick Copeland and Grady Carper decided to take advantage of the arrival of the turnpike and established the Oakwood Motor Court, which would later become the Turnpike Motel. Through the years, the locally owned motel has provided lodging for the traveling public. The motel is still locally owned and has been upgraded and remodeled with the intent to maintain the facility's 1950s vintage curb appeal with modern features that travelers now expect. (Photograph by the author.)

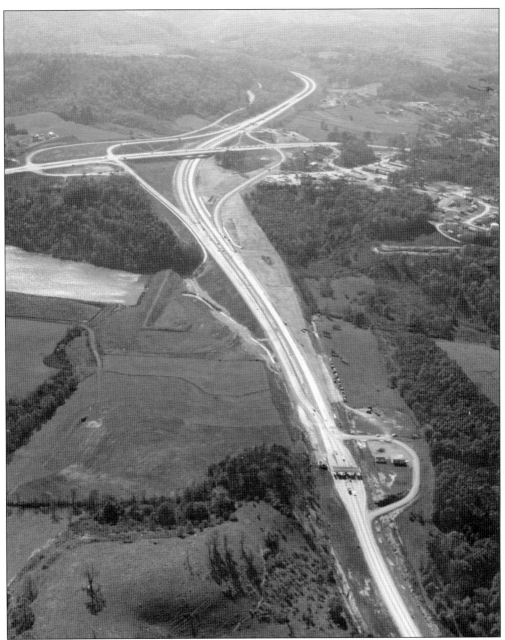

The former Exit 9 tollbooth shown here was located in a rural area almost a half-mile from the intersection with US Route 460. At the time, most of the property in the area was owned by Mercer County residents. Roughly three miles west, the Mercer County Courthouse was located near the crossroads of two major federal highways, US Route 19 and US Route 21, but the new highway was nowhere near the center of Princeton's commercial district. For that matter, the turnpike was nearly 15 miles east of Mercer County's largest city, Bluefield. Of course, when Interstate 77 connected with the turnpike in the late 1970s, Bluefield's Exit 1 was located about four miles from the interstate. The rural nature of the above photograph shows an extensive space of undeveloped property. (Courtesy of the West Virginia Parkways Authority.)

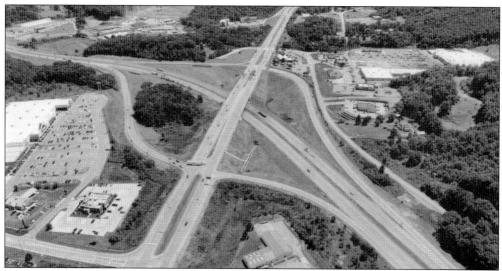

In 2022, expansion in all four quadrants of the region surrounding the West Virginia Turnpike and US Route 460 crossroads took place. The West Virginia Welcome Center, located in the upper portion of the southeastern quadrant, is situated at the entrance to a large Walmart-based shopping center with some restaurants. The southwestern quadrant includes several motels, restaurants, fueling stations, and Troop No. 6 (Beckley) of the West Virginia State Police. The northwestern quadrant includes a large home improvement store, financial institutions, restaurants, motels, Troop No. 9, and the West Virginia State Police headquarters, and the northeastern quadrant has motels and factories. (Courtesy of Randall Hash.)

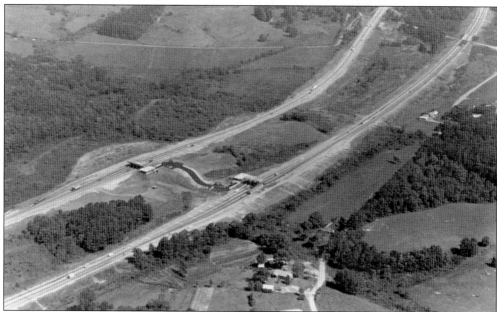

The turnpike's north and southbound tollbooths at Ghent, Exit 28, dissect a natural plateau that is flanked by the highest peak of the Flat Top Mountain range. In recent years, the region around the Ghent exit has grown with fueling stops, restaurants, WVNS-TV studios, a residential housing development, a motel, and the southernmost turnpike maintenance complex and convenience stores. (Courtesy of the West Virginia Parkways Authority.)

A ski resort on Flat Top Mountain in Ghent, Raleigh County, was originally opened as the Bald Knob Ski Resort in 1958 by Hulett C. Smith of Raleigh County, who served as West Virginia governor from 1965 to 1969. The Bald Knob resort was the second ski resort to open in West Virginia, following Canaan Valley Ski Resort. The Bald Knob slope, located on the northeast side of the turnpike, closed in 1961. New Winterplace, located at Huff Knob on the southeast side of Interstate 77, opened in 1976, and like its predecessor (Bald Knob, also known as Old Winterplace), it has earned the distinction of being the nation's southernmost ski resort. The resort's highest elevation is 3,600 feet with a vertical descent of 603 feet. There are 90 acres of skiable area and a 50-million-gallon lake with a snowmaking capacity of 7,000 gallons per minute. The 16-lane snow tubing facility (shown above) is the largest in West Virginia. (Courtesy of Winterplace.)

Snow tubing is fast developing into a popular winter adventure activity. Snow tube sleds have become more sophisticated as the popularity of the sport has grown. Tubers enjoy snow tubing adventures during the daytime as well as after dark. Tubing adventures are exciting for the entire family with options available for beginners and advanced tubers. With Winterplace's snowmaking capacity, snow tubing provides an opportunity for fun when hillsides in south-central West Virginia have no snow. (Courtesy of Winterplace.)

Winterplace is focused on family fun with 90 acres of skiable area, 28 trails, a terrain park, and 9 lifts. The ski trails extend up the northern slope of Huff Knob, in the curve of the turnpike. The terrain in front of the resort complex is devoted to beginner skiing with three chairlifts that climb midway up the ridge, providing access to mixed easier and intermediate trails. The resort's terrain park and snow summit provide access to skilled skiers for expert and intermediate terrain. (Courtesy of Winterplace.)

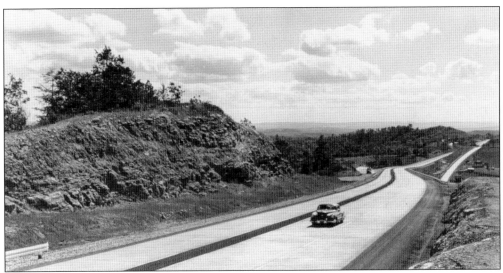

While a turnpike gives motorists the opportunity to travel from point "A" to point "B," a superhighway through the heart of south-central West Virginia opened up opportunities for developers to look into other opportunities like year-round adventure tourism or any business or industry. From the middle of the 19th century, West Virginia was known for its hardwood forests and, later that century, its abundance of coal reserves. West Virginia still has its extraction industries, but good roads bring additional opportunities with them. (Courtesy of the West Virginia Parkways Authority.)

One of those opportunities is located between Ghent and Beckley. The Glade Springs project is a prime economic development project near the turnpike. The residential community opened in 1982, followed by three highly rated golf courses—two of which are rated among West Virginia's top-five golf courses by *Golfweek* magazine—and later the Glade Springs Conference Center, which opened in 2005. (Courtesy of Randall Hash.)

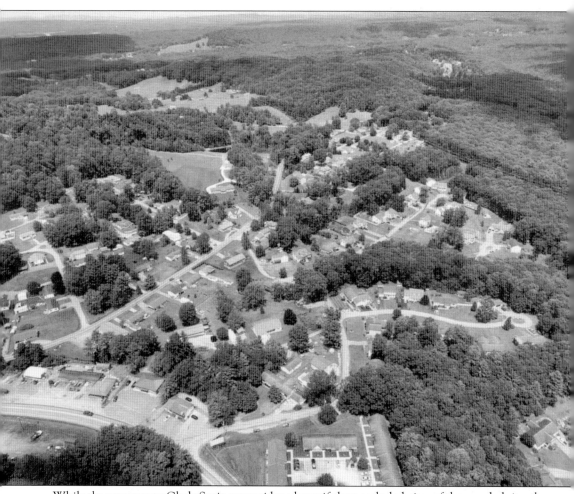

While the entrance to Glade Springs provides a beautiful yet secluded view of the wooded site, the woodlands open up within to reveal the gorgeous residential area surrounded by golf courses, pristine woodlands, and activities galore. The Cobb Course, designed by George Cobb, was rated as West Virginia's best golf course in 1995. Cobb is one of the nation's most renown and prolific golf course designers. Among other courses, Cobb designed the Tournament Players Club, the Green Island Country Club, and the Par 3 Course at Augusta National Golf Club, home of the annual Masters Tournament. Of course, the Resort at Glade Springs, located just eight miles from Winterplace, offers horseback riding and whitewater rafting on the New River. (Courtesy of Randall Hash.)

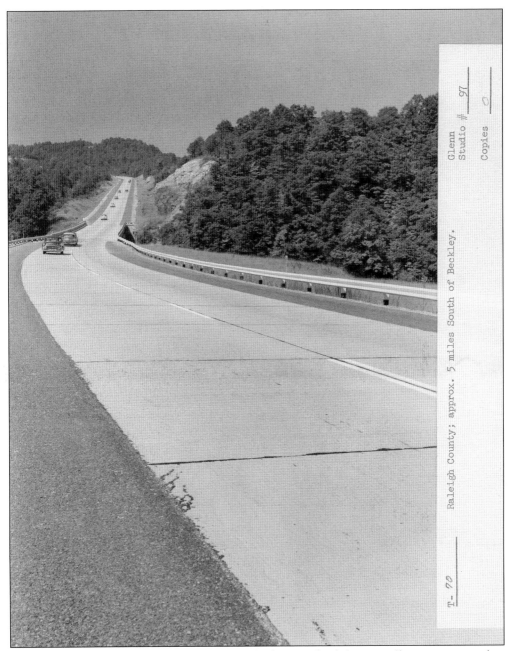

Raleigh County; approx. 5 miles South of Beckley.

Glenn
Studio # 97

Copies 0

T- 90

Developments along the West Virginia Turnpike have evolved dramatically since it opened in 1954. The photograph above, taken soon after the two-lane portion was opened in the mid-1950s, is of a site in Raleigh County approximately five miles south of Beckley. It was taken at about mile marker 39 on the approach to the massive interchange of the turnpike and Interstate 64 East. As it did in 1954, the modern turnpike still features a creeper lane, but now that former creeper lane merges into the northbound on-ramp for Interstate 64 East. While extremely vital, this interchange was an extremely complex project that was undertaken during peak travel times on the turnpike. However, modern motorists can enter Interstate 64 with ease or remain comfortably on the turnpike. (Courtesy of the West Virginia Parkways Authority.)

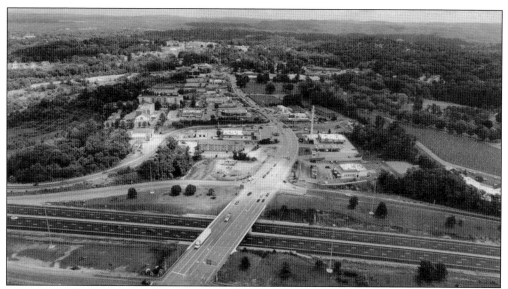

Harper Road Exit 44 at Beckley has experienced incredible growth since the opening of the West Virginia Turnpike. Harper Road, going east in the above picture, has an abundance of businesses, including motels, restaurants, shops, a hospital, and even a cemetery—Blue Ridge Memorial Gardens. To the west, Harper Road has a like number of restaurants, manufacturing firms, state entities, and motel-conference centers. Troop No. 6 (Beckley) and Troop No. 7 of the West Virginia State Police and the Department of Motor Vehicles are located out of the picture to the left. (Courtesy of Randall Hash.)

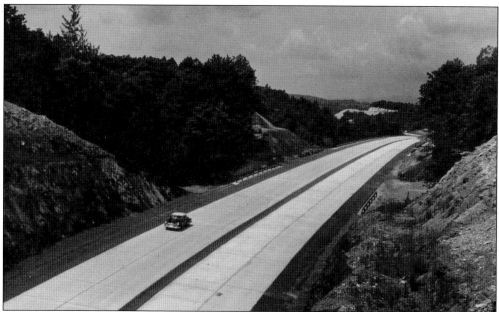

The process of expanding the turnpike to four lanes was underway, to a certain extent, during the initial construction phase. This section of the turnpike in Raleigh County featured dual creeper lanes. One of the big hurdles in terms of the initial phase of construction included the projected cost of a four-lane Memorial Tunnel and a four-lane inaugural Bender Bridge. (Courtesy of the West Virginia Parkways Authority.)

The West Virginia Welcome Center in Princeton still hosts local gatherings just as it did when Governor Caperton visited on the eventful opening celebration on October 28, 1992. Local veterans groups have a long tradition of conducting ceremonies to honor veterans of the Vietnam War. On other military holidays, including Memorial Day and Veterans Day, veterans come out to distribute coffee, soft drinks, and snacks to visitors. (Photograph by the author.)

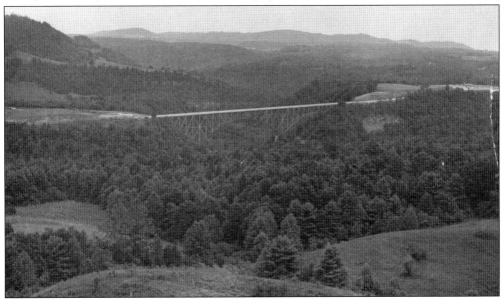

This early view of the Cornelius Charlton Bridge shows a broad view of the pristine natural beauty enjoyed by people who live in the vicinity of the highway, which serves tens of thousands of motorists daily. While the traffic flow was modest in the early years, the growth of a federal Interstate Highway System accelerated the number of daily travelers through the heart of south-central West Virginia. Sergeant Charlton's service to his nation and his supreme sacrifice are remembered by those who honor and respect all veterans . . . living or dead. (Courtesy of the West Virginia Parkways Authority.)

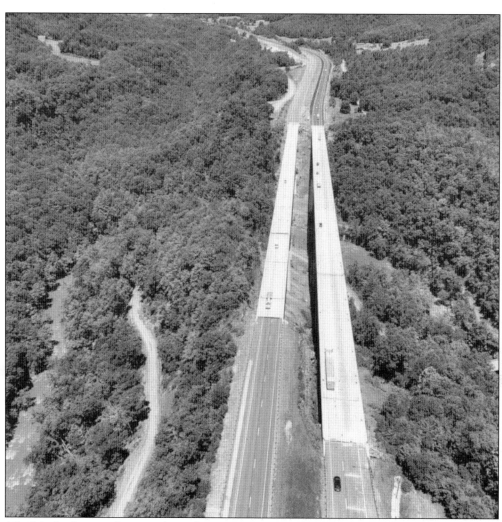

All of the bridges on the turnpike undergo constant periodic inspections and regularly scheduled resurfacing projects along with frequent inspections of the massive undercarriages of steel or reinforced concrete. In 2009, the parkways authority started a 10-year paving plan that includes using heavy overlays, which previously were installed on concrete slabs, then covered with between 5 and 10 inches of asphalt. In theory, the parkways authority will do a 1.5-inch mill and fill in a cycle across the turnpike and then follow that with a three-to-five-inch surface in a cycle. The Beckley Widening Project and other major projects are full rubberization, which includes busting the concrete slabs to make the base to install a free drain base asphalt down and then doing lifts with the other layers of asphalt up to grade, according to parkways authority general manager Jeff Miller. He added that ABC Pre-Fab deck panels are installed onto existing beams to replace bridge decks. (Courtesy of Randall Hash.)

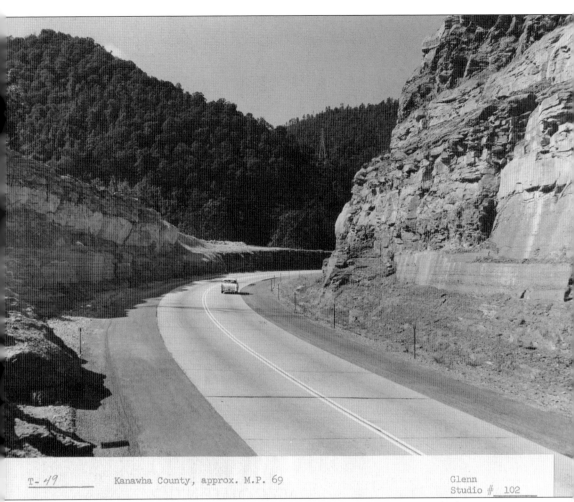

The West Virginia Turnpike has been fraught with challenges throughout its nearly three-quarters of a century history. Some motorists still drive too fast, and while rain, snow, sleet, hail, and sunshine can pound down on vehicles, the strength of a highway is in its design, construction, and ongoing maintenance. It is fascinating that the decommissioned Memorial Tunnel found new life for engineers who were designing the Big Dig in Boston and the Chunnel to connect England and France. For years, West Virginia has been known nationally as "coal country," so it should not be surprising to learn that during construction of the section to bypass the Memorial Tunnel, 300,000 tons of coal were mined from the mountain. (Courtesy of the West Virginia Parkways Authority.)

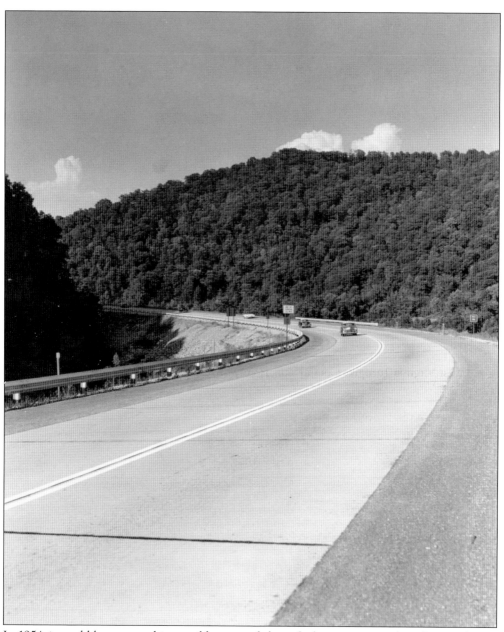

In 1954, it would have seemed impossible to travel through the mountains of south-central West Virginia in a single day, but now, the drive from Charleston to Princeton takes less than two hours. It is not just the driving time that motorists can enjoy. Any trip on the turnpike has a humbling effect of the traveling public. Of course, inclement weather can always break the mood, but with constant attention to detailed drainage, snow removal, vegetation removal, and any other of the challenges that can take place in nature, the turnpike authority board, management, and dedicated employees anticipate potential problems and address them appropriately. (Courtesy of the West Virginia Parkways Authority.)

Bibliography

De Hass, Wills. *History of the Early Settlements and Indian Wars of West Virginia*. Columbia, SC: H. Hoblitzell, 2022.

Johnson, Katherine M. *The American Road*. Lawrence, KS: University Press of Kansas, 2021.

Lewis, Tom. *Divided Highways*. Ithaca, NY: Cornell University Press, 2013.

Musson, Robert A. *Readin' Writin' & Route 21*. Medina, OH: M.D. Zepp Publications, 2010.

Pirsson, Louis V,. and Charles Schuchert. *Historical Geology*. Ninth printing. New York, NY: John Wiley and Sons, 1966.

West Virginia Parkways Authority. "West Virginia Turnpike Dedication Program." September 2, 1954.

———. "A Magic Carpet." November 8, 1954.

———. "West Virginia Turnpike Commission Twenty-fifth Anniversary." November 8, 1979.

———. "West Virginia Turnpike—Enjoy Scenic Splendor." 1982.

———. "West Virginia Turnpike From Conception to Completion." November 1987.

———. "Across the State." July 15, 1988.

———. "Driving West Virginia For 50 Years." 2004.

Williams, T. Harry. *Hayes of the Twenty-Third: The Civil War Volunteer Officer*. New York, NY: John Wiley & Sons, 1965.

DISCOVER THOUSANDS OF LOCAL HISTORY BOOKS FEATURING MILLIONS OF VINTAGE IMAGES

Arcadia Publishing, the leading local history publisher in the United States, is committed to making history accessible and meaningful through publishing books that celebrate and preserve the heritage of America's people and places.

Find more books like this at
www.arcadiapublishing.com

Search for your hometown history, your old stomping grounds, and even your favorite sports team.

Consistent with our mission to preserve history on a local level, this book was printed in South Carolina on American-made paper and manufactured entirely in the United States. Products carrying the accredited Forest Stewardship Council (FSC) label are printed on 100 percent FSC-certified paper.

MADE IN THE USA